CLARENCE GAGNON

AN INTRODUCTION TO HIS LIFE AND ART

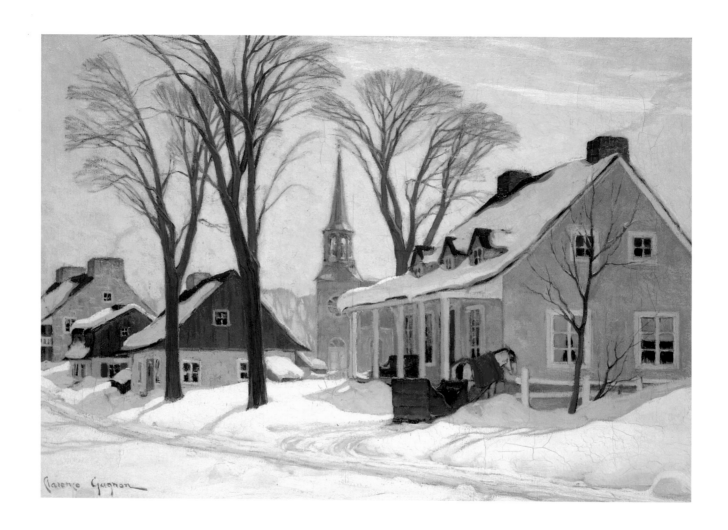

Matinée d'hiver à Baie-Saint-Paul c.1929

Oil on canvas; 54.6 x 73.7 cm. Musée national des beaux-arts du Québec. 34.148. Photo: Jean-Guy Kérouac.

Clarence Gagnon

AN INTRODUCTION TO HIS LIFE AND ART

ANNE NEWLANDS

FIREFLY BOOKS

A FIREFLY BOOK

Published by Firefly Books Ltd. 2005

First printing

The publisher gratefully acknowledges the financial support for our publishing program by the Canada Council for the Arts, the Ontario Arts Council and the Government of Canada through the Book Publishing Industry Development Program

Design by Counterpunch
Printed in Canada

Front cover: *Horse Racing in Winter, Quebec* c.1925. Oil on canvas; 104.0 x 130.8 cm. Art Gallery of Ontario, Toronto. 896. Gift from the Reuben and Kate Leonard Canadian Fund, 1927.
Back cover: *Evening on the North Shore* 1924. Oil on canvas; 77.0 x 81.6 cm. National Gallery of Canada, Ottawa. 3178. Purchased 1925.

Library and Archives Canada Cataloguing in Publication

Newlands, Anne, 1952–
Clarence Gagnon : an introduction to his life and art / Anne Newlands.

Includes bibliographical references and index.
ISBN 1-55407-081-3 (bound)
ISBN 1-55407-082-1 (pbk.)

1. Gagnon, Clarence, 1881–1942. 2. Painters – Québec (Province) – Biography. 3. Printmakers – Québec (Province) –Biography. I. Title.

ND249.G3N49 2005 759.11 C2005-900381-2

Publisher Cataloging-in-Publication Data (U.S.)

Newlands, Anne.
 Clarence Gagnon : an introduction to his life and art / Anne Newlands.
[64] p. : col. ill. ; cm.
Includes bibliographical references and index.
Summary: A general introduction to the life and art of Clarence Gagnon.
ISBN 1-55407-081-3
ISBN 1-55407-082-1 (pbk.)
1. Gagnon, Clarence A., 1881–1942.
2. Painters – Québec (Province) – Biography.
I. Title.

759.11 B 22 ND249.G2N49 2005

Published in Canada by
Firefly Books Ltd.
66 Leek Crescent
Richmond Hill, Ontario L4B 1H1

Published in the United States by
Firefly Books (U.S.) Inc.
P.O. Box 1338, Ellicott Station
Buffalo, New York 14205

Contents

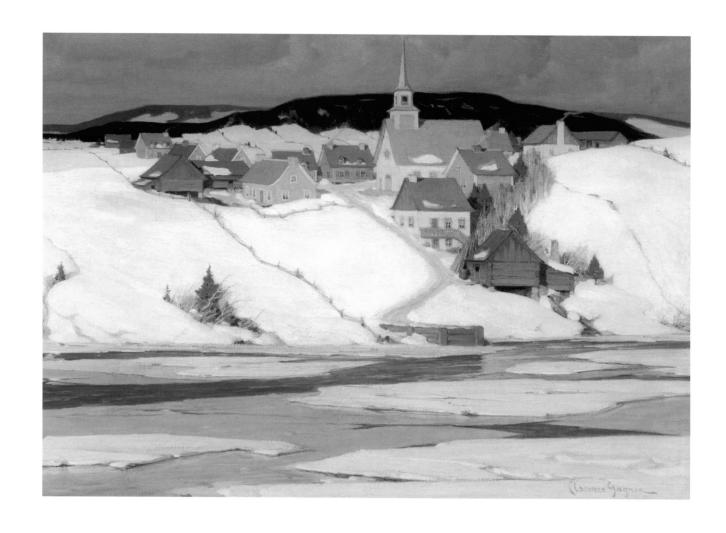

Spring Thaw, Quebec Village undated

Oil on canvas; 60.2 x 81.3 cm. Vancouver Art Gallery. 34.17.

Introduction

In the 125 years since Clarence Gagnon was born in a little village north of Montreal, the appeal of his peaceful paintings of rural Quebec has endured, conjuring affection for the old traditions and visual splendour of the Laurentians and the Charlevoix region of eastern Quebec. Best known for his images of sun-filled winter landscapes and the colourful illustrations for Louis Hémon's novel, *Maria Chapdelaine,* Gagnon was also an award-winning printmaker, whose fascination with technical perfection and craftsmanship inspired experiments in printmaking and led him later to mix his own paints. A complex and multi-talented individual, Gagnon's varied interests, skills and passions frequently competed with the time for his art. As a passionate outdoorsman and a *bon vivant,* he filled his photo albums with images of fishing, skiing, hiking and sailing that all reflected his intense enthusiasm for nature. Despite the many years of living abroad, his love of the picturesque villages and dramatic landscapes of the Charlevoix region fostered his interest in the domestic arts of the habitants. These people were descendants of French peasant farmers, and their geographical isolation perpetuated their adherence to traditions largely untouched by industrialization. Gagnon's friendship with them led to his active promotion of Quebec handicrafts, along with his contribution of designs and colour schemes to improve the quality of local products. "All art is fine art," he wrote, "and no art worthy of the name can lose caste by assisting the other arts."

His involvement in the 1920s with Eric Brown, Director of the National Gallery of Canada, and his association with some of the Group of Seven artists, enhanced his pride in his French-Canadian identity and reinforced the contributions of fellow Quebec artists to the story of Canadian art. Gagnon's astute observations of the life, art and politics that surrounded him are recorded in his abundant correspondence, giving us insights – in both English and French – into his personality and preparing us for the burst of eloquent speeches delivered later in life. Characterized by his friend the poet Duncan Campbell Scott as "an intense and untiring craftsman in whatever he undertook," Gagnon's concentrated "thoroughness" was balanced, as many others have also noted, by a spirit of optimism that similarly illuminated his art.

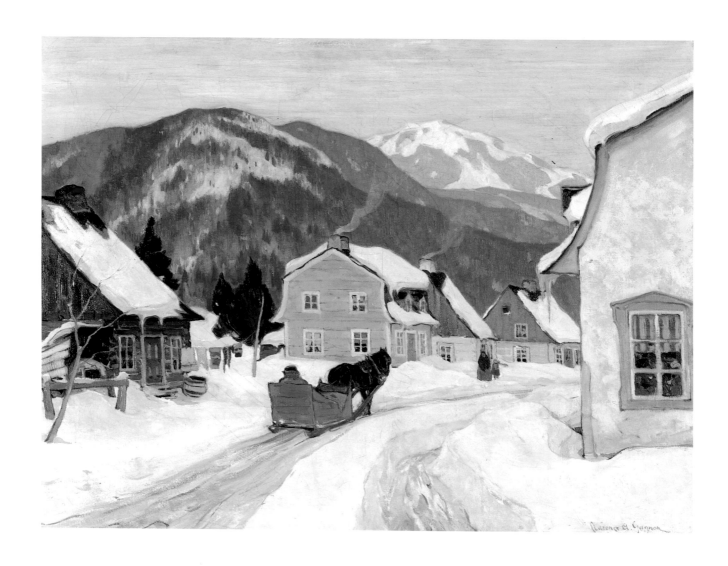

Laurentian Village 1921–27

Oil on canvas; 73.0 x 92.0 cm. Musée national des beaux-arts du Québec. 34.637. Photo: Patrick Altman

One: The Formative Years

Clarence Alphonse Gagnon was born on November 8, 1881, in the village of Sainte-Rose, Quebec, on the banks of the Mille-Îles River, just north of Montreal. His father, Alphonse-Edmond Gagnon, a descendant of a Norman family that had come to New France in the seventeenth century, managed the Ogilvy flour mills in Montreal and provided a comfortable middle-class living for his family. His mother, Sarah Ann Wilford, was born in England and is said to have had musical and literary talents. Although she died in 1889 when Clarence was eight years old, she is credited with introducing him to the biblical engravings of Gustave Doré, which may have inspired his early interest in drawing.

Like many other nineteenth-century middle-class families, the Gagnons arranged for photographs of their children in William Notman's Montreal studio. In the photograph (right,) the five-year-old Clarence, accompanied by a younger sister, is the very image of late Victorian propriety. He is depicted in front of a backdrop of a painted landscape, a foreshadowing of the subject that would dominate his artistic career. Three years later Clarence's mother died, and in 1891 his father remarried and the family moved to Montreal. Despite his father's disapproval and dashed hopes for a son who would follow him into business, Clarence began his art studies at the École du Plateau in the studio of Louis-Philippe Hébert.

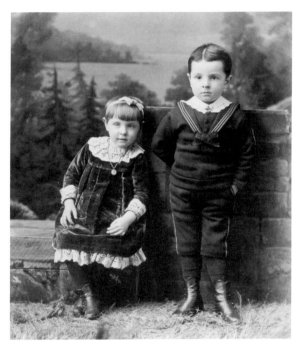

Mrs. A.E. Gagnon's Children, Montreal, QC 1886. *Notman Photographic Archives, McCord Museum of Canadian History, Montreal. II-79702.1.*

EARLY MENTORS: BRYMNER AND WALKER

In 1897, at the age of sixteen, Gagnon began studying with William Brymner, at the Art Association of Montreal. A generous aunt provided the tuition

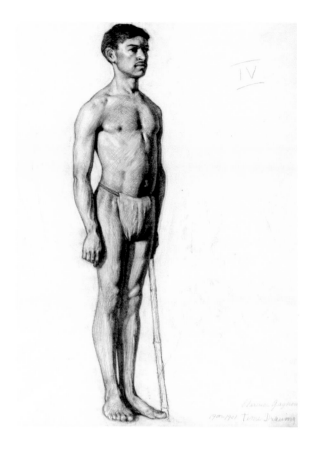

drawing, Gagnon learned to make careful studies of human anatomy, giving attention to the play of light and dark on the three-dimensional form. Gagnon's success secured him a scholarship for his last two years of study with Brymner.

While in France, Brymner had painted in the forest of Fontainebleau, about 50 kilometres southeast of Paris, an area popularized by the Barbizon painters (so-called for the nearby village of the same name). There, artists such as Jean-François Millet sketched out of doors, *en plein air,* portraying rural life and landscape unsullied by the burgeoning industrialization of the city. Soon after his return to Canada in 1886, Brymner travelled to Quebec's lower St. Lawrence region near Beaupré, to the Île d'Orléans, and to Baie-Saint-Paul, painting rural folk and farm life. His influential works paved the way for Gagnon and other artists to pursue Barbizon subject matter on Canadian soil.

On Brymner's advice, in 1901 Gagnon and his friend, the painter Edward Boyd, travelled east of Quebec City to Saint-Joachim at the foot of Cap Tourmente. The following year, Gagnon returned to the region and met Horatio Walker, an Ontario-born artist who summered on a farm at Sainte-Pétronille on the Île d'Orléans. Known as the "American Millet," Walker enjoyed critical and financial success in the United States and Canada for his heroic depictions of rural life. Gagnon spent some time at Walker's, making sketches for future work and becoming better acquainted with the artist who would become a lifelong friend and mentor. Gagnon also took many photos of farmers in the fields and of women engaged in domestic tasks – material he later integrated into his paintings.

In works such as *Oxen Ploughing, Beaupré* (page 12),

denied by his father. Following studies at the Académie Julian in Paris and many years travelling in Europe, Brymner had returned to Montreal in 1896 to become, by the early 1920s, one of the city's most influential teachers. His students revered his advice to study nature by cultivating a personal response to it, remembering, as he wrote in 1895, that the artist must learn "to express his emotions in the way he feels will best make them felt by others, although he is not following anyone's example."

Gagnon's *Academia* (above), the drawing of a standing man dated 1900, attests to the training that he received under Brymner, who imported the tradition of the French academies to Montreal. Focusing on

Gagnon was directly inspired by Walker's magnificent Barbizon-like paintings such as *Ploughing, the First Gleam at Dawn* (page 13), in which a herdsman, lit by the rising sun, guides the oxen. Focusing on the diffused play of light across the land and the isolation of the farmer toiling in the field, Gagnon eschews the theatricality favoured by Walker, and instead offers a simple, timeless image of rural work. Following Gagnon's move to Paris in 1904, Brymner wrote to him announcing that Gagnon's work had won a bronze medal at the World's Fair in St. Louis, Missouri. The work was promptly purchased by the Art Association of Montreal, later the Montreal Museum of Fine Arts.

CHARLEVOIX

In the summer of 1903, Gagnon travelled farther down the St. Lawrence River into the Charlevoix region, stopping at Baie-Saint-Paul, whose quaint charm and picturesque setting made an indelible impression on him. Established in the late seventeenth century, Baie-Saint-Paul is nestled in the fertile valley of the Gouffre River. The region, named for the Jesuit historian Pierre-François-Xavier de Charlevoix (1682–1761), lies on the north shore of the St. Lawrence, about a hundred kilometres east of Quebec City. (See map.) In the late eighteenth century, military artists recorded its topography and, by the 1840s, steamships brought tourists to the region seeking cures, and adventure, from the mountain air and salty waters. Artists capitalized on the improved transportation and, attracted by its dramatic beauty, went there to paint. Like many, Gagnon was drawn to the region's rugged coastline, sparkling fishing streams and forests for hunting. Mostly, he was fascinated by the life in the village,

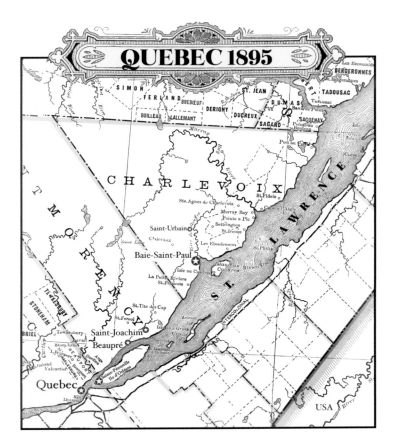

where people continued to live in the fashion of their ancestors. Whether he knew it at the time or not, Gagnon had discovered his painting place. Just as Walker had claimed the Île d'Orléans and as Tom Thomson would embrace Algonquin Park, Gagnon would stay faithful to the Charlevoix region for the rest of his life.

Gagnon's paintings of rural themes attracted the interest of James Morgan, the prosperous Montreal department store owner, whose purchase of works and financial sponsorship permitted Gagnon to go to Paris to study. Morgan provided his fare and a monthly allowance of seventy-five dollars. In exchange, Gagnon was to send twelve pictures a year for display and sale in Morgan's store gallery.

Map of eastern Quebec (detail). Adapted from Cram's Standard American Atlas.

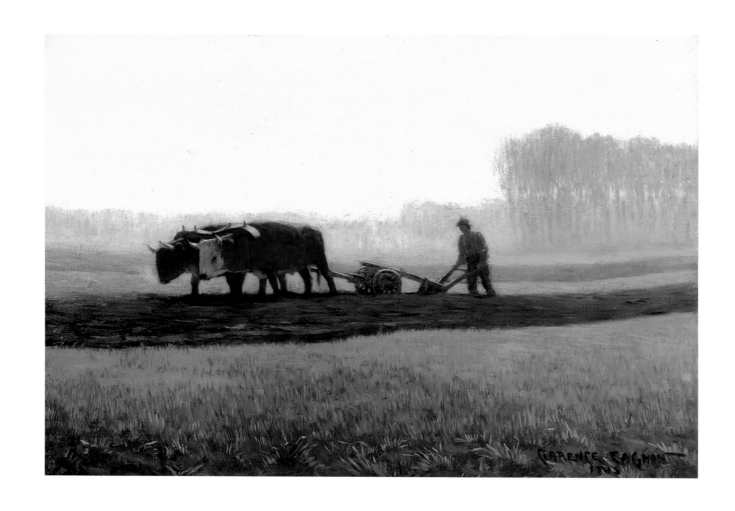

Oxen Ploughing, Beaupré 1903

Oil on canvas; 51.1 x 71.4 cm. The Montreal Museum of Fine Arts. 1952.1067. Gift of Dr. J. Douglas Morgan
in memory of his father, James Morgan. Photo: MMFA/Marilyn Aitken.

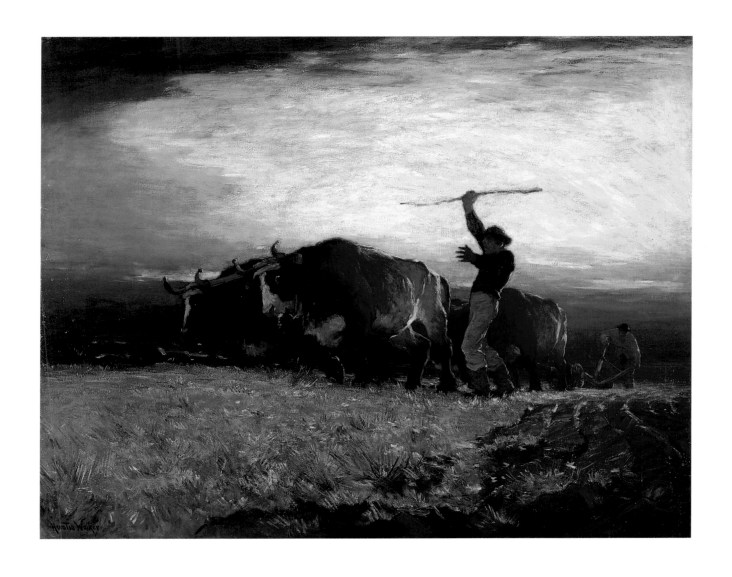

Horatio Walker: *Ploughing, the First Gleam at Dawn* 1900

Oil on canvas; 153.0 x 193.4 cm. Musée national des beaux-arts du Québec. 34.530. Photo: Patrick Altman.

Autumn, Pont-de-l'Arche 1905

Oil on canvas; 65.4 x 92.3 cm. The Montreal Museum of Fine Arts. 1909.56.
Gift of James Morgan. Photo: MMFA/Marilyn Aitken.

Two: Paris, 1904–1914

Since the middle of the nineteenth century, Paris was the primary destination for ambitious artists from Europe and North America seeking a reputable artistic education. Paris offered the government-sponsored École des beaux-arts, official exhibiting Salons, and a system of private academies such as the Académie Julian where many Canadian artists studied under the leading artists of the day. Paris also offered famous museums, at which to study the art of the past, and commercial galleries to see the latest trends. When Gagnon arrived in the winter of 1904, the ideas of avant-garde modernists such as Paul Cézanne, Paul Gauguin and Henri Matisse were on the rise. These artists, however, were of little interest to Gagnon, who was more attentive to what was being shown in the official Salons – an art of a moderate modernism that fused academic art with the palette and spirit of the Impressionists.

Without a permanent address, and seeking to establish his visibility quickly in Paris, Gagnon joined the American Art Association, a social club for artists and art students, with a library and exhibition rooms. Soon after, he travelled to Spain with his friend Edward Boyd, rather than enrolling promptly at the Académie Julian. In letters to Morgan he complained of living expenses in Paris, and by July he decided to rent a room at Pont-de-l'Arche, a small village near Rouen, about two hours

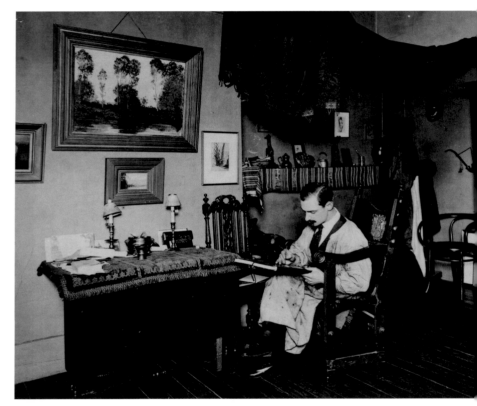

Gagnon in his studio, 9 rue Falguière, Paris. *National Gallery of Canada Archives, Ottawa. 030820.*

by train from Paris. Although the Académie Julian had initially been his principal objective, his studies there with Jean-Paul Laurens were brief. After a few months, Gagnon went his own way.

GAGNON AND MORRICE

Of the many Canadians Gagnon encountered in Paris, the internationally acclaimed James Wilson Morrice, had the most singular and enduring impact. A former student of Brymner's who had lived in Paris since 1889, Morrice was widely acclaimed for his sensitive use of colour and refined composition. In his 1938 speech on Morrice, Gagnon noted the very qualities that he strove for in his own work, his "poetic conceptions … charm and atmosphere, light, exquisite colour and delicacy of feeling." Gagnon sketched with Morrice in Paris, and adopted his method of painting quickly on the spot, using small wooden panels. Favouring public places such as cafés and municipal gardens, Gagnon learned to capture the fleeting effects of light and shadow with a minimum of means, retaining these visual "notes" as departure points for studio canvases. Gagnon also admired Morrice's palette. He gradually abandoned the earth tones of paintings like *Oxen Ploughing* (page 12) and embraced brighter, more saturated, colours to evoke the brilliant light of northern France and, later, the radiant luminosity of Quebec's Laurentian Mountains.

PAINTING

Gagnon's early French paintings made use of his newly acquired brightened palette and show his exploration of the countryside in a variety of settings. In *Autumn, Pont-de-l'Arche* (page 14), produced the year after his arrival there, Gagnon painted a serene view of a meadow fringed with yellow-leafed trees that sway gently in the wind. In the distance, the graceful Pont-de-l'Arche defines the horizon line dividing the blue sky from the expanse of green field. With the solitary figure of the woman with her basket, an air of quiet permeates the painting and recalls, though with more intense colour, the pastoral landscapes of Camille Corot, whose work Gagnon greatly admired.

Possibly at the suggestion of Morrice, Gagnon explored the coast of Brittany, stopping to sketch at the fashionable beaches of Saint-Malo, Dinan and Dinard, places already made famous by the Impressionist precursor Eugene Boudin and his student, Claude Monet. In August 1907, Gagnon wrote to Morgan: "I have some very important news to tell you. I am engaged to be married here on the 2nd of December at St. Sulpice to Miss Katryne Irwin. I have changed about to a new sketching ground … my first real try at painting the sea and the life around the *plages* …" Photographs from Gagnon's album show him frolicking at the seaside with friends and Miss Irwin, a former student of Brymner's whom Gagnon had met in Montreal. In *The Beach at Dinard* (page 17), two women with children cluster in the foreground in the shade of the tents that dot the beach. The vivid colours convey the luminosity of the sea, sky and sun and suggest the joy of summer leisure and the excitement of new beginnings for Gagnon.

In the paintings of 1908, Gagnon returned to Barbizon-type pictures of rural life in the Normandy countryside. *The Goose Girl* (page 18) demonstrates Gagnon's fascination with the effects of light. Here the late afternoon sun creates a warm flickering pattern on the frieze of autumn trees behind the young woman. Dressed in traditional clogs and a white cap, she casts a long shadow behind her while patiently shepherding her wandering geese.

During this first period in France, Gagnon travelled widely throughout the French countryside as well as in Spain, Italy and England, making sketches for paintings

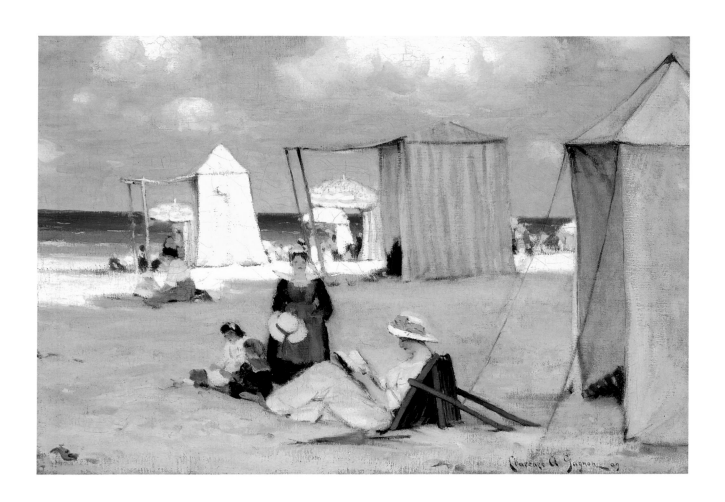

The Beach at Dinard 1909

Oil on canvas; 43.2 x 61.0 cm. The Montreal Museum of Fine Arts. 1975.12. Gift of the
Honourable and Mrs. Joseph-Édouard Perreault. Photo: MMFA/Brian Merrett.

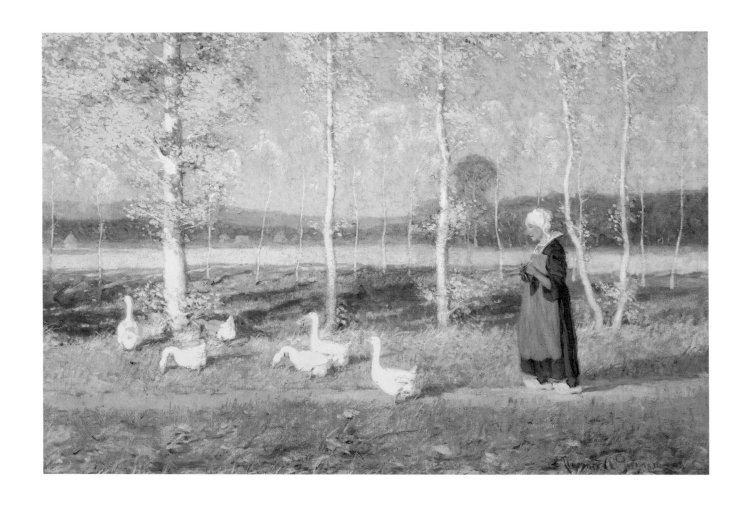

The Goose Girl 1908

Oil on canvas; 63.5 x 92.0 cm. The Montreal Museum of Fine Arts. 1989.54. Gift presented
in memory of Amy Wilson Southam Ker (1896-1942) by her children. Photo: MMFA.

Le Jardin d'Horatio Walker à Sainte-Pétronille, Île d'Orléans 1908

Oil on canvas; 38.0 x 50.8 cm. Musée national des beaux-arts du Québec. 78.50. Photo: Patrick Altman.

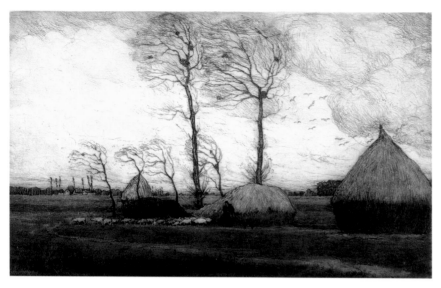

November 1905

Etching; 16.2 x 23.2 cm (paper), 13.5 x 20.9 cm (image).
Musée national des beaux-arts du Québec. 34.158. Photo: Patrick Altman.

and prints whose foreign subject matter would seem exotic to Morgan's clients in Montreal. In contrast, his painting, *Le Jardin d'Horatio Walker à Sainte-Pétronille, Île d'Orléans* (page 19) was inspired by a sketch made during his 1902 visit with Walker and suggests a longing for home. The two artists shared a love of gardening and, in the years to come, would exchange seeds and bulbs, along with advice. Here Gagnon explores the pure colours of the Impressionists with a delicate palette of blues and greens but eschews their loose brushwork, maintaining his preference for a more realistic depiction of nature.

PRINTMAKING

In the second half of the nineteenth century, many painters in Europe and North America participated in a revival of the art of etching. Etching was an attractive medium for original artistic expression, and as a multiple it allowed for a wide dissemination of an artist's work, benefiting both reputation and income. Artists of Gagnon's generation were highly influenced by the refined, atmospheric prints of James Abbot McNeill Whistler, the ex-patriot American who had lived in Paris. Morrice had known Whistler and, with Gagnon, shared an admiration for his stark drawing style and harmonic arrangements of colour and tone.

The success of Gagnon's paintings was, interestingly, due to the international acclaim for his etchings – works that were not initially part of his ambitions in going to France. Throughout this first French period, 1904–1909, Gagnon worked simultaneously on painting and printmaking – reserving rural and coastal scenes, where colour was pre-eminent, for painting; and views of quaint villages and urban sites, where architecture was more dominant, for etching.

Gagnon was introduced to etching by Donald Shaw MacLaughlan, an artist he met at the American Art Association. MacLaughlan, a highly regarded American artist-etcher in the early years of the twentieth century, encouraged Gagnon to draw directly on the varnished metal plate in much the same way that the Canadian had made oil sketches for painting. Gagnon would make initial sketches on the small plates on site and then rework the image in his studio, as we see in the photograph on page 15. MacLaughlan also taught him to consider the use of particular inks and papers to achieve specific effects, thus prompting Gagnon's lifelong passion for investigating artistic techniques. Early in his etching career, Gagnon made a "test plate," on which he recorded his experiments with different needles, acids and room temperatures, each of which could affect the quality of an image. As Albert Robson remarked in his

monograph on the artist, Gagnon did nothing "by halves … In his etchings there is apparent a perfect mastery of this difficult medium, with sure and sensitive draughtsmanship, fine composition and infinite artistry."

Gagnon's thirty-four etchings are a testimony to his extensive travels and keen observations. With an eye on the market for picturesque views of European sites, in etching as in painting, Gagnon selected places that reflected the ways of pre-industrial societies. Gagnon would discover that the market for these images, especially ones as beautifully executed as his own, was vast. Canadian collectors eagerly sought images of Europe, and Europeans cherished mementos of their own quickly disappearing past – now threatened by growing industrialization and urbanization.

One of Gagnon's earliest and most poetic etchings, *November* (page 20), shows judicious inking of the plate to increase the emotional impact. In the foreground, densely inked lines evoke the weight of the sodden ground, while the sky above is wiped clean to heighten the fragile austerity of the trees tossed by the wind.

Many of Gagnon's etchings attest to his travels outside France to well-known tourist spots. Inspired by Morrice's oil sketches and Whistler's celebrated etchings of Venice, Gagnon would have been eager to add images of it to his repertoire. In *Canal San Pietro* (above right), Gagnon worked directly on the plate, capturing with exquisite delicacy the effects of light on the boats, buildings and quivering canal waters which gently dissolve in the fog, evoking the magical elusiveness of Venice. Critics were united in their praise for the "astonishing virtuosity" of Gagnon's series of Venetian prints.

Back in Paris in late 1906, Gagnon was invited by MacLaughlan to pull a series of prints from some old Rembrandt plates that MacLaughlan had been given

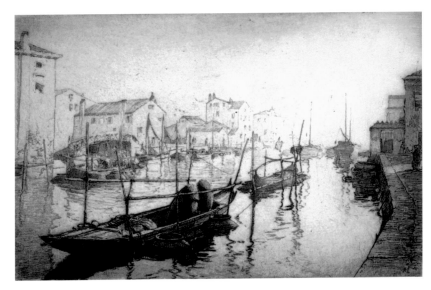

Canal San Pietro, Venice 1907

by a friend. Gagnon would have seen this as a great opportunity to learn first-hand from an artist whose work was unparalleled in its emotional expressiveness. This contact inspired Gagnon to make three prints of windmills that evoke both the rural Dutch countryside and the sombre drama of Rembrandt's work. In *The Storm* (page 22), the finely drawn foreground of farm buildings is lightly inked, establishing a peaceful foil to the jagged blades of the windmill and torrents of rain that fall from the coarsely drawn sky.

Like many other artists, Gagnon was attracted to the picturesque tourist spots in northern France. His view of the island abbey of Mont Saint-Michel (page 23) juxtaposes its mirage-like majesty against the earthy reality of the thatched roofs and muddy lanes of the village in the foreground. As he later wrote to his friend Duncan Campbell Scott, this print was "the best one I ever scratched."

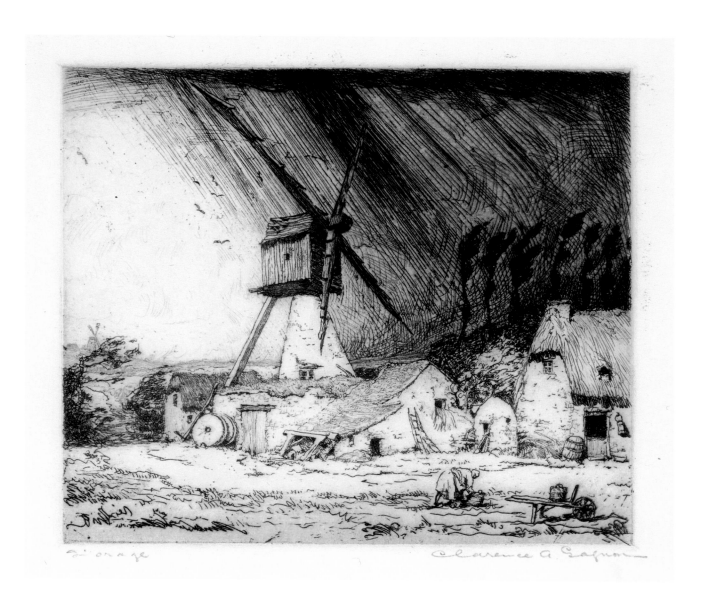

The Storm 1907

Etching; 19.9 x 25.4 cm (paper), 14.2 x 16.4 cm (image). Musée national des beaux-arts du Québec.
34.169. Photo: Jean-Guy Kérouac.

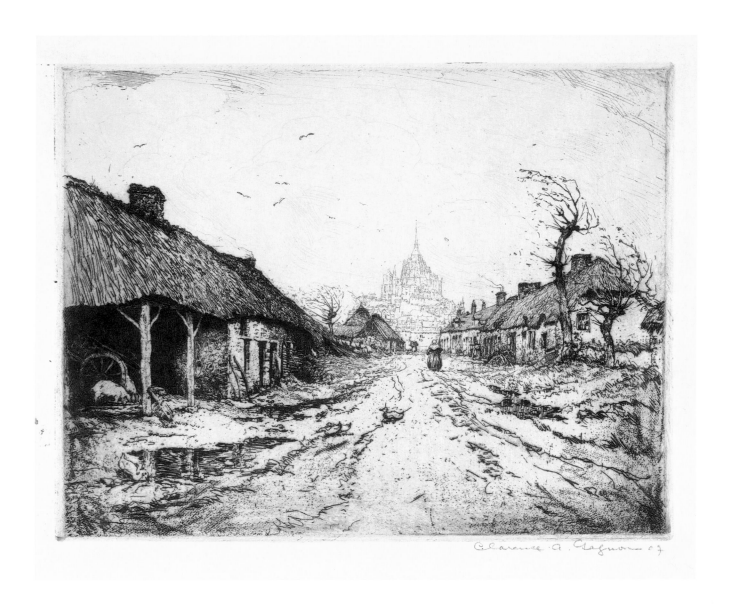

Mont Saint-Michel 1907

Etching; 25.1 x 29.4 cm (paper), 20 x 25 cm (image).
Musée national des beaux-arts du Québec. 77.322. Photo: Patrick Altman.

Gagnon's foray into etching was an unqualified triumph and established his international reputation as one of the greatest etchers of his time. Exhibitions in the Paris Salons and critical acclaim by the French press ensured his prestige and increased his marketability at home. Following an exhibition in 1906 at the American Art Association in Paris, his work drew the attention of the *Gazette des Beaux-Arts,* an art journal with a strong interest in etching. The critic declared that, "among these new etchers, the most talented and deeply artistic seems for the moment to be Clarence Gagnon … [O]ne can easily discern … the careful effort at arrangement and the felicitous contrast of light and shadow characteristic of his prints." Later, his Venetian etchings received honourable mention at the Spring Salon of the *Société des artistes français.* The publicity that followed drew the attention of international collectors and museums in London, Berlin, Munich, Paris, Amsterdam, New York and Montreal, all keen to expand their collections of artists' views of Europe. Gagnon's reputation as a celebrated etcher endured for the rest of his career even though he would very soon abandon the medium.

A Visit to Canada

Early in 1909, after a five-year absence, Clarence returned with Katryne for a short visit to Montreal. She was able to see her family and Gagnon, having decided to terminate his contract with Morgan, found a new dealer in Johnson and Copping. During this visit he made one etching of a Canadian subject, *Le Lac, Séminaire Saint-Sulpice.* Then, to everyone's surprise, he retired from etching. Although he would continue to pull prints from his old plates into the mid 1920s, he ceased making any more compositions.

Interviewed many years later, Gagnon stated very clearly that the reason "I could not go on with etching was the lack of colour. What always attracted me in French Canadian life was the abundance of colour in the lives of the habitant." Soon Gagnon would be committed to a large exhibition of his paintings in Paris and knew that "only the natural scenery of Canada, especially our Canadian winter … interests them on this side; and the brush can do far more than the needle in giving the variety of effects of our glorious Canadian winters."

In the summer of 1909, Clarence and Katryne took the newly established train to Baie-Saint-Paul, and Gagnon began to build lasting relationships with several local people: Xavier Cimon, with whom he lodged; Dr. Euloge Tremblay, who had just opened his practice; and Judge Simard, who would invite him sailing along the St. Lawrence River. He also befriended Henri Tremblay, a skilled carpenter. After setting up his studio in Tremblay's shop, Gagnon began to decorate his frames – experimenting with stencils and hand-painted motifs taken from nature. Gagnon also became keenly interested in handicrafts of the village, where women spun, dyed and wove their own wool for hooked rugs and clothing.

Shortly before his return to Paris, Gagnon painted *Autumn Scene, Baie-Saint-Paul* (page 25). The compositional format in this work is similar to that of his European work of this period: horizontal bands of colour define the water, land and sky and are contrasted with the steeply sloping roofs of the village houses. Uniting the composition, the tall poplars soar skyward and cast their reflections in the river. The delicate palette of greens, mauves and yellows shows Gagnon's eyes still bathed in the colours of French Impressionism.

Autumn Scene, Baie-Saint-Paul 1909

Oil on canvas; 73.0 x 91.0 cm. The Montreal Museum of Fine Arts. 1988.7. Gift of the Succession J.A. Desève.
Photo: MMFA/Richard-Max Tremblay.

Farm on a Hill c.1912

Oil on canvas; 51.0 x 66.4 cm. Art Gallery of Ontario, Toronto. 2328. Gift of Reuben Wells Leonard Estate, 1935.

Return to France

Clarence and Katryne returned to France in the fall of 1909 and, despite his growing commitment to the Charlevoix region, Gagnon continued to see himself as a Paris artist. At the same time, he highly valued his associations with Canada. He was glad to be invited to become a member of the Canadian Art Club (1907–15), aligning himself with the most progressive artists of the day, among whom several – Horatio Walker, James Wilson Morrice and Homer Watson – also had international reputations. Writing in *The Studio* in 1910, Eric Brown, who would soon become the director of the National Gallery of Canada and a lifelong supporter of Gagnon, acknowledged his "greatness abroad," and praised his "artistic facility … The colour is always clear and fresh, and there is a spontaneity and optimistic truth." The same year, Gagnon was elected an associate of the Royal Canadian Academy of Arts.

The Reitlinger Exhibition

Near the end of 1909, A.M. Reitlinger, the owner of one of Paris's largest and most influential galleries, offered Gagnon a solo exhibition that would open in late 1913. He encouraged Gagnon to produce images of the Laurentian winter, an intriguing subject to Europeans. For Gagnon, familiar with the thawing rivers of Suzor-Coté and the foggy winter skies of Maurice Cullen, the challenge was to create a view of winter that was distinct from those of his countrymen.

In the years between 1910 and 1913, Gagnon travelled frequently between Paris and Montreal, spending the springs and summers from 1909 to 1911, and the early winter of 1912, in Baie-Saint-Paul. Exploring

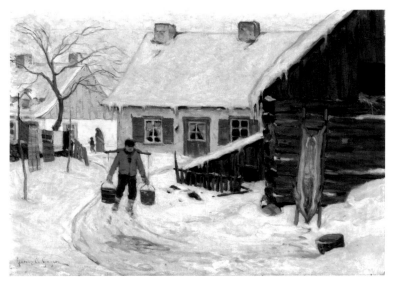

Jour de boucherie 1913

Oil on canvas; 53.5 x 73.8 cm. Musée national des beaux-arts du Québec. 34.149.
Photo: Jean-Guy Kérouac.

the Laurentian countryside and villages by foot and on skis, he made oil sketches of the rural architecture and traditional activities of the men and women. He also continued to take photographs as *aide-memoires* for use in his Paris studio. In the four years of preparation for this one exhibition, Gagnon produced almost half of his lifetime output of paintings on canvas. The exhibition catalogue lists seventy-five paintings, fifty-four of which were dedicated to images of Canadian winters and village life. In contrast to earlier works, these paintings transport the viewer to a more specific experience of the Charlevoix region, revealing perhaps Gagnon's increased emotional engagement with the people and the land.

In *Farm on a Hill* (page 26), a snow-covered road snakes into the valley below, where houses dot the perimeter of a field. Recalling the muted colour symphonies of Whistler, Gagnon employs a palette with

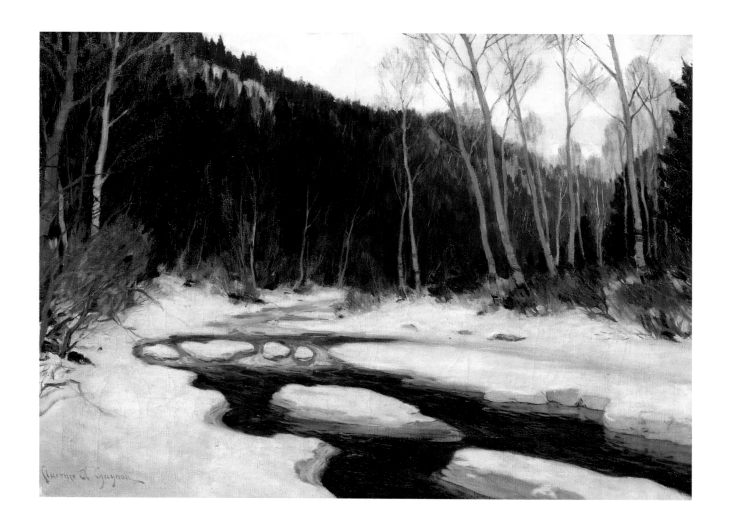

L'Hiver dans les Laurentides 1911

Oil on canvas; 61.6 x 82.0 cm. Musée national des beaux-arts du Québec. 34.577. Photo: Jean-Guy Kérouac.

a limited tonal range. Here, varied shades of blue describe foreground shadows and link our eyes to the distant violet-blue hills crowned by a soft aqua-green sky. In creating the image in his Paris studio, Gagnon looked to a photograph of the house on the Rang de l'Equerre outside Baie-Saint-Paul. However, in the painting he crops the view of the house and artfully exaggerates the twisting road to create a more dynamic composition.

In contrast to the feeling of open space of *Farm on the Hill*, in *Jour de boucherie* (page 27) we look closely at one of the seasonal rituals of rural life. Here, the lone figure of a man balancing pails of water advances along a snowy path where the carcass of a freshly slaughtered pig is splayed on a ladder. Since the shadowy foreground is the place of death, the sun-filled background, with its gaily painted houses and hand-woven articles on the clothesline, is life-affirming.

As a passionate outdoorsman, Gagnon welcomed opportunities to ski beyond the village limits in search of subjects for his paintings. In *L'Hiver dans les Laurentides* (page 28), a thawing river draws us into the thick woods like a curving road into a village. Opposing the flat, open, blue-whiteness of the banks of snow in the foreground, the trees in the distance are an intricate tapestry of blue and mauve that trap the light in the density of the forest. As art historian François-Marc Gagnon observes, Clarence Gagnon's unpopulated landscapes were far from the savage wildernesses later to be portrayed by the Group of Seven. He painted instead "a small, quiet area, a place of refuge, a peaceful sanctuary … that little piece of forest that the habitant kept at the edge of his land for the needs of his farm."

Although the sales from the Reitlinger exhibition were meagre (five paintings and some etchings),

the show successfully established Gagnon's reputation as a painter of tranquil Canadian winter scenes. In French periodicals – from *La Gazette des Beaux-Arts* to *Le Petit Parisien* – critics were unified in their praise of Gagnon's pictorial sensitivity to light and colour. Writing in *La Canadienne*, Jean Bardoux extolled Gagnon's "fresh impressions, infinitely clear and luminous … M. Clarence Gagnon is very skillful. His work is picturesque, exact and spiritual." With his characteristic thoroughness, Gagnon also designed, painted and decorated the frames for every painting in the exhibition. Built by his carpenter friend Henri Tremblay, the frames were painted in dark colours to contrast with the bright colours of the paintings. In addition, Gagnon stencilled the frames with patterns of the fauna and flora of Charlevoix, reflecting his admiration of the region's folk art traditions and endowing the exhibition with a distinctly French-Canadian flavour.

Early in 1914, Reitlinger organized the exhibition *Peintres de neige* (*Painters of Snow*) and invited Gagnon to display his works with a dozen other artists. The art world's passion for winter scenes was boundless. The very year Gagnon had his 1913 solo exhibition at Reitlinger's, future Group of Seven artists Lawren Harris and J.E.H. Macdonald marvelled at the representation of winter in an exhibition of contemporary Scandinavian painting in Buffalo, New York. While these artists were greatly moved by the Scandinavian artists' spiritual and decorative approach to the landscape, Gagnon would remain rooted in his *terroir* with a nostalgic depiction of the cultivated areas of rural French Canada.

Sections of frames stencilled and hand decorated by the artist. Courtesy Musée de Charlevoix, Quebec.

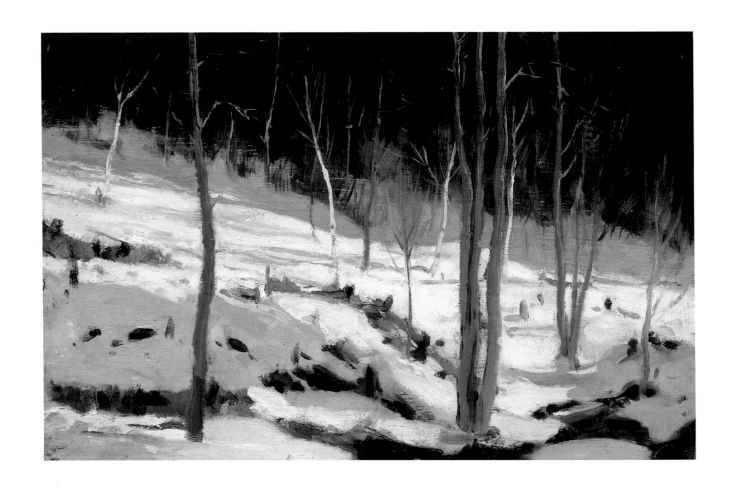

Clearing, Charlevoix 1915

Oil on panel; 15.5 x 23.0 cm. Musée national des beaux-arts du Québec. 88.113 Photo: Jean-Guy Kérouac.

Three: Baie-Saint-Paul, 1914–1924

The years during which Gagnon painted feverishly for the Reitlinger exhibitions were essential for his career, but hard on his marriage. In the summer of 1914, just before war erupted in Europe, Clarence and Katryne returned to Montreal. For reasons that have yet to come to light, they were living apart by the fall. Uncomfortable in Montreal social circles – his divorce was now pending – Gagnon retreated to Baie-Saint-Paul and resumed sketching in oil on small panels. These sketches would serve as details or sources of inspiration for future canvases and, although he did not know it yet, for the illustrations for Louis Hémon's landmark novel about rural life in northern Quebec, *Maria Chapdelaine*. There, in the quiet of the countryside, he could forget the war and his temporary unhappiness.

The small panel studies from this period reveal Gagnon's attraction to peaceful, open spaces that emanate a feeling of solitude. In *Clearing, Charlevoix* (page 30), Gagnon captures the rhythmic play of sun and shadows in a forest clearing, using rose and soft blues to convey the brilliance of the light. Exploring different vantage points, he produced harmonic colour studies of distant valleys, as we see in *Overlooking the Vallée du Gouffre, Charlevoix* (page 32), as well as more focused views of the region's architectural features. All are pervaded by an air of quiet that soothes the viewer, even when the colour is startling as in *La Maison rouge,*

Charlevoix (page 33). In the directness and simplicity of these works, Gagnon achieved the expressive poetry that he so admired in Morrice.

In *Near Baie-Saint-Paul* (page 34), time stands still as children playing in the snow on the outskirts of Baie-Saint-Paul are dwarfed by the distant blue hills. Attentive to the changes of the seasons, Gagnon hints here at the coming of spring. A thawing stream and laundry hung to dry near the yellow house promise fairer weather. Canvases like this one display a type of composition that Gagnon would continue to favour, and vary, for decades to come: small figures, often with their backs to us, punctuate a winding snow-covered road, dots of humanity lending scale and life to a rural village landscape still free of the electrical and telephone wires of modern society.

Although Gagnon was not a religious person, it is certain that he recognized the spiritual drama of the view of Baie-Saint-Paul from the vantage point of the wayside cross that dominates the height of land at Cap-aux-Corbeaux. Wayside crosses, prevalent in eastern Quebec, were symbols of the faith of the local people, Roman Catholic for centuries. In the shaded foreground of *The Wayside Cross, Autumn* (page 36), a solitary gray cross, complete with the instruments of Christ's torture, stands like a sentinel above the sunlit valley where farms and fields create a harmonious patchwork

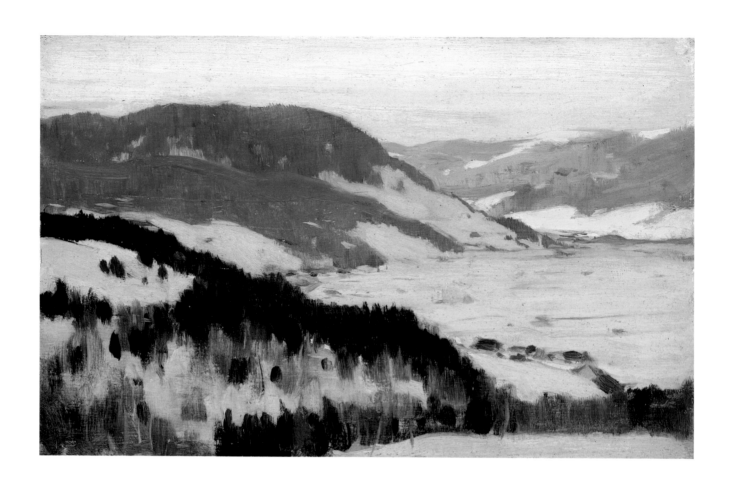

Overlooking the Vallée du Gouffre, Charlevoix c.1915

Oil on panel; 12.0 x 18.0 cm. The Montreal Museum of Fine Arts. 1988.26. Dr. Max Stern Bequest.
Photo: MMFA/Brian Merrett.

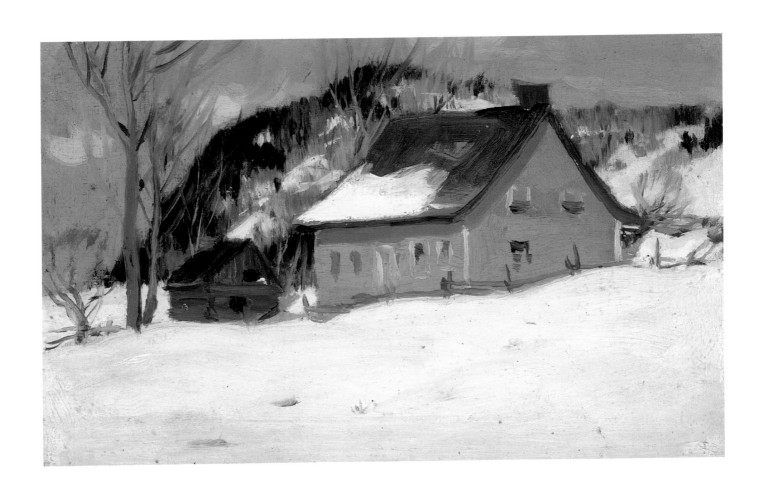

La Maison rouge, Charlevoix 1915

Oil on wood panel; 11.6 x 18.0 cm. Musée national des beaux-arts du Québec. 46.111. Photo: Patrick Altman.

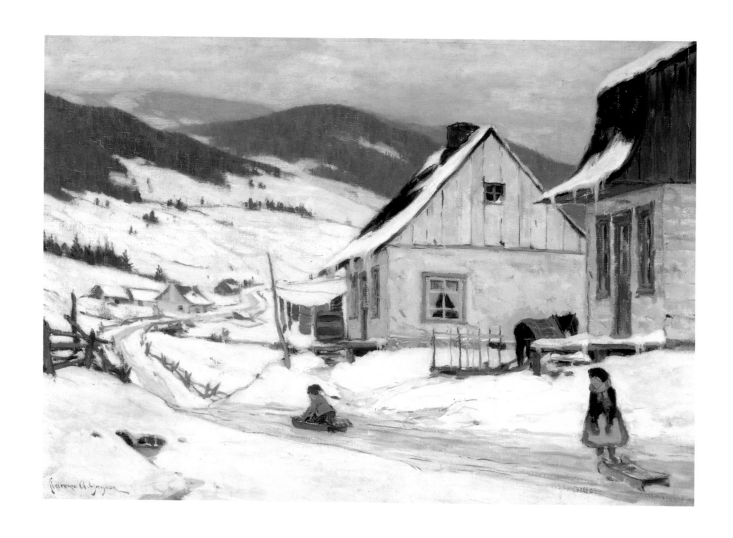

Near Baie-Saint-Paul 1912–15

Oil on canvas; 54.0 x 73.2 cm. Musée national des beaux-arts du Québec. 34.147. Photo: Patrick Altman.

of pinks, greens and oranges. Beyond, mauve-blue hills dissolve in the luminosity of the blue-pink sky completing the passage from the real to the ethereal. Critics praised the work in their reviews of the Royal Canadian Academy exhibition of 1916, noting that "the artist has shown his usual skill in managing the delicate tones of mellowed sunlight." Purchased the same year by the National Gallery of Canada, the painting acknowledges Gagnon's affection for the beauty of the Charlevoix region, rendered in a moderate modernism appreciated during the war years in Canada.

In contrast to the open grandeur of many of the Charlevoix paintings, Gagnon's *Street Scene, Quebec at Night* (page 37) evokes the more confined spaces of the city. In the cool blue-green light of the moon, two large trees cast their skeletal shadows on the side of the house whose mass dominates the surface of the canvas. The feeling of cold is evoked by the dark sky and blanket of snow, but the orange light from a single window provides a beacon of warmth and refuge.

Despite the war and the decline of the art market, Gagnon maintained his profile through exhibitions. In 1915, he sent ten works with Italian and Spanish subjects to the Panama-Pacific exhibition in San Francisco and also exhibited with the Royal Canadian Academy and at the Salmagundi Club in New York. Working on Canadian subjects in Baie-Saint-Paul, he anticipated a return to the European market and remained eager to return to his Paris studio. Finally, disregarding the war and the promise of difficult, if not dangerous, living conditions, Gagnon sailed for France in May 1917, blithely reporting to Eric Brown that the "submarines don't seem to worry those who want to get on the other side."

PARIS, 1917–1919

"Things are very quiet here," Gagnon wrote to Brown upon his arrival in May 1917. "Paris seems almost normal though we can hear at times the sound of the guns. I had a very uneventful trip across and was very glad to be in my studio once more. I expect that military pictures are doomed to failure. People are so sick of the war, nobody wants to hear or see anymore about it. Works of art and antiques are still up in prices, no chance for bargain hunters!"

By the summer of 1918, Gagnon's personal life showed signs of changing. During a visit to Reitlinger's country estate he travelled to a Red Cross camp to see Lucile Rodier, who was working as an ambulance driver for the Allies. Thirteen years his junior, Lucile came from a comfortable Montreal family and had studied briefly in Paris, where she met Gagnon before the war. Although the war's end in November 1918 brought a conclusion to the hostilities, life in Paris remained hard, given the scarcity of food and fuel and the outbreak of the Spanish flu epidemic. Gagnon returned to Montreal in May 1919.

RETURN TO BAIE-SAINT-PAUL, 1919–1924

The hardship of life in postwar Paris was not the only reason for Gagnon's return to Montreal. He was also eager to reconnect with Lucile Rodier, who had recently arrived from France. Lucile's mother did not approve of the relationship, however, and, after the couple married in June 1919, she withdrew financial support from her daughter. Lucile seemed undeterred and faithfully embarked on a life in the service of her husband's art and career.

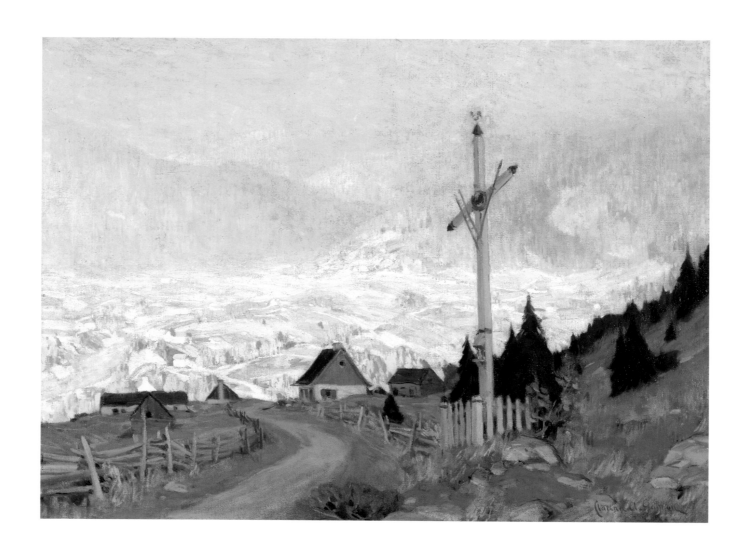

The Wayside Cross, Autumn c.1916

Oil on canvas; 56.0 x 74.5 cm. National Gallery of Canada, Ottawa. 1367. Purchased 1916.

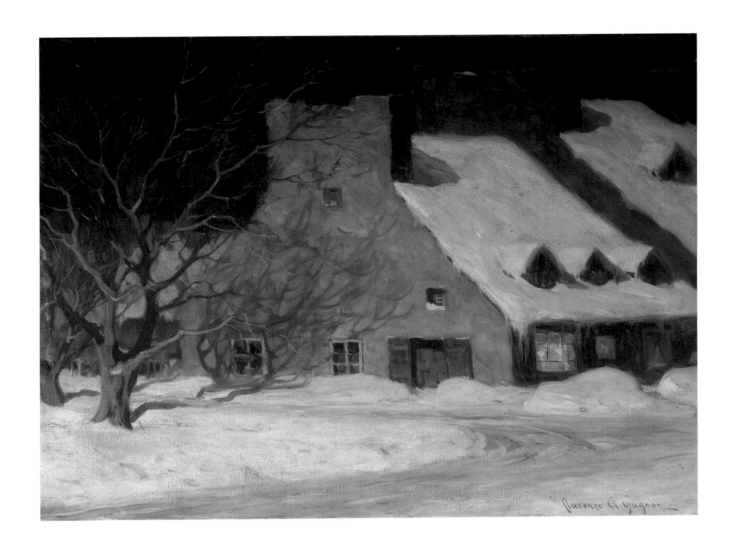

Street Scene, Quebec at Night c.1917

Oil on canvas; 56.4 x 74.4 cm. National Gallery of Canada, Ottawa. 1449. Purchased 1917.

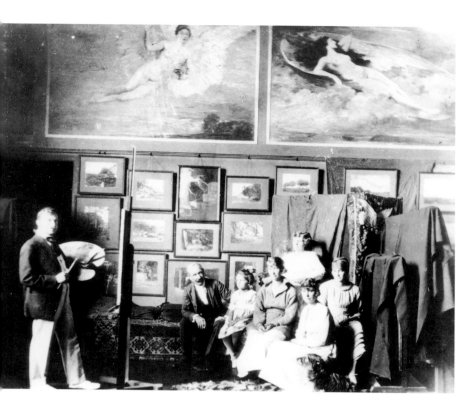

Gagnon and friends in Horatio Walker's studio 1919. *Archives of Ontario, Toronto. F 1075-9-0-21, S 10156, Ao 7239.*

On their return to Baie-Saint-Paul, but before settling there for most of the next five years, Clarence and Lucile paid an extended visit to Horatio Walker, who now lived permanently on the Île d'Orléans. In a photograph taken in Walker's studio in the summer of 1919 (above), Gagnon poses as if to paint a portrait of Walker, who is seated with Lucile (front-row centre) and members of Walker's family. Although Gagnon complained of Walker's demanding social regime and its intrusion on his painting time, he did encounter prominent Canadians who would become lifelong friends and supporters of his work. He met Major (later Governor General) Georges Vanier and his wife Pauline Archer, as well as the poet and head of the Department of Indian Affairs in Ottawa, Duncan Campbell Scott, with whom he would become a close friend and frequent correspondent.

At the end of August, Gagnon wrote to Scott: "In a week I shall be down at Baie-Saint-Paul where I shall roam about the wilds in quest of game and subjects to paint. There is a constant fight between my gun and my palette. It always ends with both winning out … My stay here has done my health worlds of good. I shall be able again to face the cold when I start again on my skis to hunt up snow pictures."

Gagnon and Lucile took the train to Baie-Saint-Paul and were lent a small house at the back of an estate belonging to Rodolphe Forget, a wealthy Montreal financier. They dined frequently with Dr. Tremblay and his family, who were aware of the couple's limited resources. If living conditions were sparse, Gagnon's output was not, and during this period he produced many of his most beautiful works. As an extension of his fondness for the people and the landscape of the Charlevoix region, he also became more involved in the local handicraft scene.

In *The Ice Bridge, Québec* (page 39), one of Gagnon's most dazzling canvases, a procession of farmers on horse-drawn sleighs laden with produce make their way to market across an ice bridge from the Île d'Orléans to Quebec City. Since the nineteenth century, whenever conditions of extended cold prevailed, patches of the St. Lawrence River would freeze sufficiently to allow a road to be traced across the frozen surface. Identified by the tops of pine trees positioned along the path – or "bridge" – it offered expeditious travel in the winter months. Here, with a deftness of touch and an Impressionist palette of complementary colours, Gagnon renders the effects of the sun with thin orange lines on the edges of the pines, sleighs and blankets and harmonizes these with blue-mauve

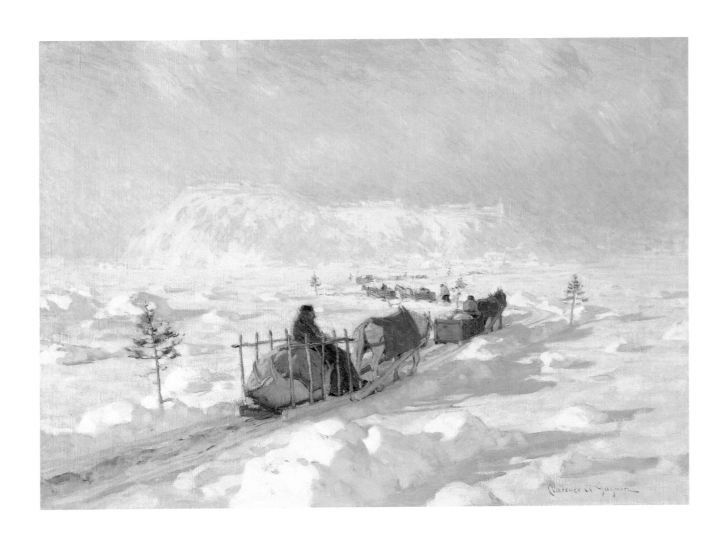

The Ice Bridge, Québec 1919 or 1920

Oil on canvas; 56.4 x 74.5 cm. Musée national des beaux-arts du Québec. 34.636. Photo: Patrick Altman.

March in the Birch Woods 1920

Oil on canvas; 73.7 x 91.4 cm. Art Gallery of Ontario, Toronto. 104.
Gift of the Canadian National Exhibition Association, 1965.

shadows cast along rose-tinted snow. In the distance, the snow-covered rocky mass of Cap Diamant dissolves in a magical glow. In the words of one reviewer: "It's morning and the sun on the snow is so bright that you are tempted to put your hand over your eyes so as not to be blinded."

A 1921 letter to Scott affirmed Gagnon's source of inspiration as slightly at odds with what is depicted in the painting. "We stopped on our way down a couple of days at Jacques Cartier Lodge on the Island," he wrote. "It is a rather interesting experience crossing the ice bridge which runs from his [Walker's] place straight across to the mainland. Very picturesque to see the caravan of 'habitants' in their sleighs going to Quebec, winding their way through this hummocked ice surface." In the canvas, Gagnon has created a long and meandering road to Quebec City's lower town, when in reality the ice bridge probably went directly from the western tip of the Île d'Orléans to the less picturesque mainland coast near Beauport.

Gagnon's enchantment with the luminosity of winter in Charlevoix is also evident in *March in the Birch Woods* (page 40), where glorious sunlight permeates the wooded landscape topped by a joyous turquoise-blue sky.

THE CRAFT OF ART

Gagnon often wrote of his frustrations with premixed artists' paints that darkened and cracked and compromised the artist's original intentions. "Colours and artists' materials we get now are very poor," he wrote to Scott early in 1921, "and it more than exasperates one to find oneself so handicapped when such beautiful effects of light and colour play around one." In another letter to Scott, written in the spring of 1921,

Gagnon announced, "It was only a few weeks ago that I have found out after six years of experimenting and analyzing what is wrong with artists' colours made since the beginning of the war ... In future I shall grind my own colours and will not be fooled by these colour-makers who are after all nothing but chemists and artists who have failed."

In a speech, "Theory and Chemistry of Colour," presented to the Arts Club in Montreal in 1937, Gagnon spoke of his research into paint mixing – describing particular oils, pigments and "grinding" surfaces – and provided advice about restoring pictures. Copious hand-written notes, now in the McCord Museum's archives, record his meticulously dated experiments and list the results of mixing a single pigment (pure colour) with a variety of oils such as linseed, Japanese wood, poppyseed and egg. Emulating the achievements of the old masters in producing paintings that endured for centuries, Gagnon lamented the passing of the old apprenticeship system. Even in sombre pictures such as *Evening on the North Shore* (page 42), Gagnon reaped the benefits of mixing his own colours. Here, small houses and barns hug the rocky shore where the richly coloured red and green foliage enlivens the harshness of the mauve-gray rocks.

Gagnon's quest for technical excellence extended from his painting to his gardening. In letters to friends he writes of experiments with particular seeds and bulbs, many of which he exchanged with Walker. In correspondence to Scott, he tells of his invention of an irrigation system to stem the severe drought, and later of his success with sweet peas that reached a remarkable height. In his 1942 tribute to Gagnon, Scott reflected on the artist's dedicated craftsmanship that was combined with his "fundamental thoroughness, a determination

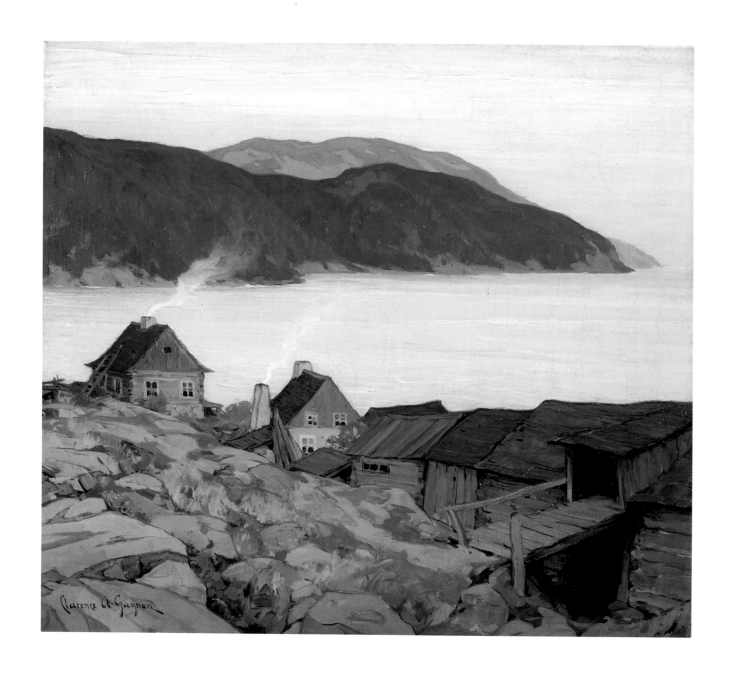

Evening on the North Shore 1924

Oil on canvas; 77.0 x 81.6 cm. National Gallery of Canada, Ottawa. 3178. Purchased 1925.

to understand and control, and a stubborn reliance on himself, governed by a reverence for tradition."

THE ART OF CRAFT

Gagnon was attracted to the old customs of habitant life not only as a subject for his art, but also as a reflection of his desires to see the traditions of rural Quebec preserved. In a letter to Scott in March 1921, Gagnon commented on the effects of postwar recession on the people of Baie-Saint-Paul: "The habitants here are going back to homemade 'stuff.' The bread ovens are being rebuilt, and we hear the song of the spinning wheel and the loom. The high cost of living does not worry them very much ... Necessity will restore a part of the picturesque aspect of that old Quebec." In his 1945 monograph, *Clarence A. Gagnon*, Albert Robson added that Gagnon believed "that the preservation and encouragement of these fine old native industries would add both profit and pleasure to the life of the rural inhabitants. Sitting around with the habitants in the evenings, he worked out colour schemes for their homespun carpets or made beautiful designs for their hooked rugs."

In addition to the artistic partnership with Henri Tremblay, initiated in 1909 for the frames for the Reitlinger exhibition, Gagnon advised various women weavers and rugmakers and arranged for their work to be exhibited outside the region. In a letter to Scott, he wrote, "I have the habitants here working again on the looms. By helping them with colour and design, they are turning out most interesting work and some of them carried off first prizes at the Toronto Fair." Believing that "there is no reason why the simplest articles of household effects should not be beautiful,"

Gagnon advocated collaborations between artists and craftspeople, adding that the artist must have "a practical appreciation of the matter for creation." In his ever-thorough manner, he embarked on learning the technique of weaving. Writing to Scott in December 1923, he announced, "I unpacked the two looms you were so kind to send me ... I wish you and Mrs. Scott could see the homespun I have made here lately ... I will send you some samples."

In the *Hooked Rug* (page 45), one of several women with whom Gagnon collaborated in Baie-Saint-Paul (the specific maker is unknown) has skilfully hooked out of wool the plump, feathered bodies of two grouses that frolic among the more delicate and linear foliage. Executed in a limited palette of browns, greens and reds, it shows the simple, focused composition that Gagnon recommended for objects such as this one. A rug of an identical design was exhibited in the 1927 Montreal exhibition of the Canadian Handicraft Guild, an important supporter of handicrafts and Aboriginal art from across the country.

Gagnon was not the only artist in the early 1920s to paint in the Charlevoix region or to take an interest in the local handicrafts scene. His old friend A.Y. Jackson, a former student of Brymner's who Gagnon had met in Paris in 1905, had been sketching in Quebec since 1921. Jackson had first visited Gagnon in Baie-Saint-Paul in 1923, and in January 1924 he returned with Montreal artists Edwin Holgate, Mabel May and Lilias Torrance Newton. Back in the region later with another Montreal artist, Albert Robinson, Jackson noted that the villages were changing: shingle roofs were replaced with metal, oil furnaces spelled the end of the wood pile, and cleared roads in winter invited motorized vehicles to replace the sleighs of old. Writing in his 1958

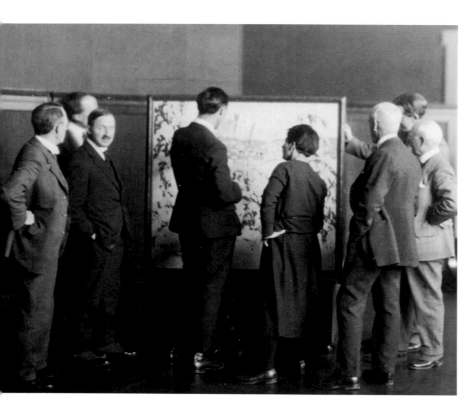

jury duties. Two years later, Eric Brown, director of the National Gallery of Canada, invited him to participate – along with Horatio Walker, Arthur Lismer, Florence Wyle and four others – in the jury for the 1924 British Empire Exhibition in Wembley, England. It was a process fraught with dissension, as the older jury members, the "old moss bags" as Gagnon called them, remained hostile to the "modern" paintings of the Group of Seven. In the photograph of the Wembley jurors examining a painting by Lawren Harris (left), Gagnon, aligned with the younger artists, looks at the camera assured, for the time being, in his support of the Group.

In the summer of 1924, Gagnon reported to Scott: "I may have to go back to Paris next winter to see about my studio there. If I don't go back and occupy it, I may be forced to give it up … I want to go over some time when I have sufficient studies and documents to work up for two to three years in my studio in Paris; and at the same time give Lucile a change from this lonely country." In his typically spontaneous manner of travel, Gagnon made his arrangements at the last moment and sailed for France with Lucile on December 10, 1924. Just days before his departure, Gagnon sent Walker some dahlia and gladiolus bulbs along with detailed descriptions of flower petals and colours.

Gagnon in Wembley Jury, Ottawa 1924. National Archives of Canada, Ottawa. PA 122343.1979-232. Photo: Hands Studio.

autobiography, *A Painter's Country*, Jackson said, "While Robinson and I, in our paintings, accepted all the contemporary types of buildings which made the old Quebec villages a jumble, Gagnon, steeped in the traditions of Quebec, in his compositions would replace the new wooden boxes with old houses of which he had many studies."

The Baie-Saint-Paul years between 1919 and 1924, which were enriching for Gagnon's development, were also important for Canadian art. In 1920, the formation of the Group of Seven in Toronto triggered a debate over the nature of Canadian art and polarized the more conservative artists against the younger, more forward-looking groups and individuals. In 1921 Gagnon was elected a full member of the Royal Canadian Academy of Arts, with voting privileges and

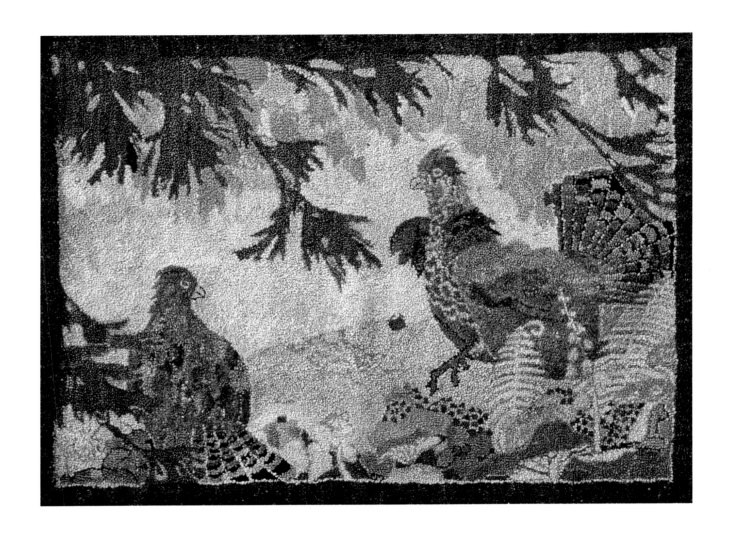

After Clarence Gagnon *Hooked Rug* c.1924

Wool on burlap; 67.0 x 91.0 cm, irregular. National Gallery of Canada, Ottawa. 38245.

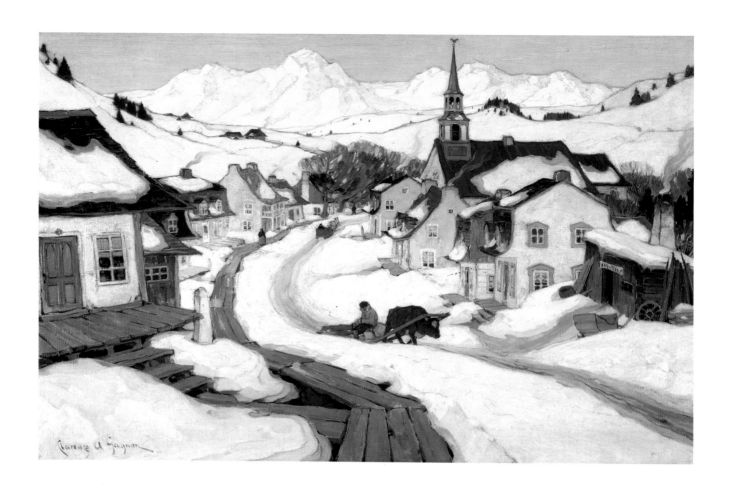

Village in the Laurentian Mountains 1925

Oil on canvas; 89.2 x 130.7 cm. National Gallery of Canada, Ottawa. 3529. Purchased 1927.

Four: Return To Paris, 1924–1936

The next twelve years of Gagnon's third European sojourn were among the busiest of his life, but not just with painting. Established now as a friend of Eric Brown and conveniently situated in Europe, Gagnon became heavily involved in helping Brown organize a second exhibition at Wembley in 1925. Returning to Paris to find his studio "in a terrible state," he wrote of having to paint "day and night to get something ready for Wembley."

Removed for a second time from the environment of his inspiration, Gagnon's Parisian studio work is generally a little stiffer and less atmospheric than the work executed at Baie-Saint-Paul in the early 1920s. In *Village in the Laurentian Mountains* (page 46), which was exhibited at Wembley in 1925, Gagnon's love of rural architecture is reflected in his vibrant colours and attention to the details of the curved mansard and peaked roofs, the massive chimneys and the varied window framing. Gagnon presents a fictionalized view of the village of Saint-Urbain, putting a curve in the main street and exaggerating the size of the Mont du Lac des Cygnes in the distance. When the Montreal dealer William R. Watson, commented that the mountains looked more like the Alps (where Gagnon had been recently sketching) than the Laurentians, Gagnon quipped, "What's wrong with that? They've got the best of two worlds." In fact, Gagnon tended to recompose landscapes in

Gagnon smiling, standing at *Maria Chapdelaine* exhibition, Ottawa 1938. *Black and white photograph; National Gallery of Canada Archives, Ottawa. Print II – XII – 79.*

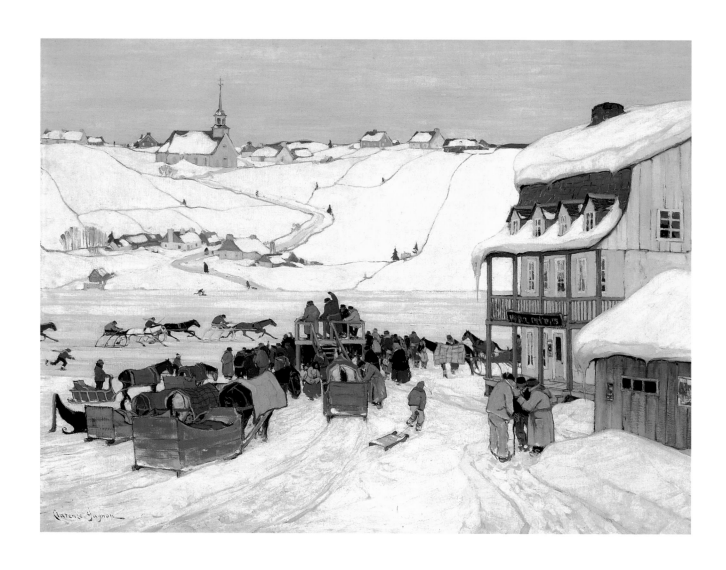

Horse Racing in Winter, Quebec c.1925

Oil on canvas; 104.0 x 130.8 cm. Art Gallery of Ontario, Toronto. 896.
Gift from the Reuben and Kate Leonard Canadian Fund, 1927.

the manner of the classical landscape artists, and as he himself had in *The Ice Bridge, Québec* (page 39). Writing later in his "Visual Sense Data" notes, he explained, "Even if a great deal of the landscape is given to the artist, he nevertheless arranges it, reshapes its constituent parts, and introduces new elements."

The critics' enthusiastic response to the Group of Seven at Wembley in 1925, and the claim by the Group's promoters, that their art was the embodiment of the Canadian national spirit, was objectionable to Quebec artists such as Gagnon. Writing to Brown in 1926, he said, "The trouble comes from the word 'seven' which was unfortunate for the Group to use … They appear to want outside artists to fight for them, but they don't want these in their group … as it is, the Montreal men do not relish the dictatorship of the Group of Seven." Responding to the release the following year of Fred Housser's book on the Group, *A Canadian Art Movement,* Gagnon was indignant and vociferously protested Housser's oversight of Quebec painters such as Maurice Cullen, who "was tramping on snow-shoes in the Laurentians and exhibiting in Paris pine trees, frozen rivers … when Lawren Harris was still at his ABC's." At the same time, Gagnon appreciated the Group's work, and, especially, Tom Thomson's. "Personally I have great admiration for their paintings," Gagnon wrote to Brown in 1927, "but condemn their method of propaganda which smells too much of politics."

The second Wembley show was no sooner finished than Eric Brown approached Gagnon to work with him and the French government to organize the first large exhibition of Canadian art in France. Two years later, in 1927, the *Exposition d'art Canadien* opened at the Jeu de Paume in Paris, a huge exhibition of 250 works that included Thomson and Morrice retrospectives. Writing to Scott a few months before its opening, Gagnon complained of being too busy: "I do not seem to be able to find time to do any painting, and yet I am anxious to do something new for this show. I have hundreds of pictures in my mind."

Of the eight works exhibited by Gagnon at the Jeu de Paume, some were from previous years and others, such as *Horse Racing in Winter, Quebec* (page 48), were derived from earlier oil sketches. In that work, the image of people and sleighs clustered along the shoreline recalls the dense knotting of people seen in paintings by Cornelius Krieghoff a century earlier. The red sleigh anchors the foreground and sets the stage for a panoply of other brightly hued sleighs and horse blankets – vivid against the snowy valley, frozen river and cool white sky. Indifferent to the pleas of A.Y. Jackson, who urged him in 1926 to "come home and paint Quebec before it is all turned to garages and gas stations," Gagnon worked from his sketches in his Paris studio, faithfully perpetuating a nostalgic view of pre-industrial Quebec. In summer, however, when Paris was quiet, homesickness seeped into his letters to Brown. "I would give a good deal to be at Baie-Saint-Paul wading in those cool streams tickling trout," Gagnon wrote in one letter. "I wonder sometimes why I ever left …"

BOOK ILLUSTRATION

Le grand silence blanc

Throughout the hectic period of the Wembley and Jeu de Paume exhibitions, Gagnon painted when he could and, in 1925, accepted an invitation from the French publisher Les Éditions Mornay to illustrate Louis-Frédéric Rouquette's adventure novel, *Le grand silence blanc.* Sensitive to the requirements of colour

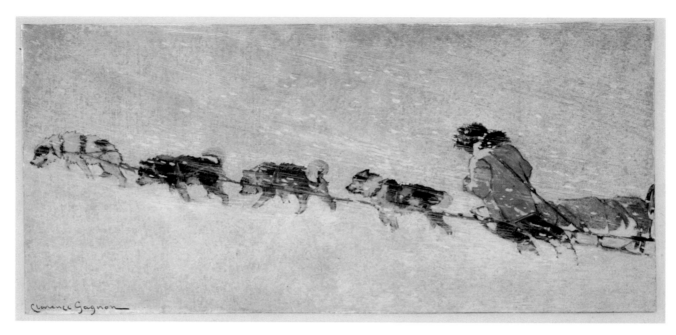

Dog Team 1927

Monotype on wove paper, mounted on wove paper; 15.3 x 32.1 cm. National Gallery of Canada, Ottawa. 3559. Gift of the artist, Paris, 1928.

printing, Gagnon initially attempted to prepare wood-block prints as templates for the printers, but failing to obtain the right wood, among other difficulties, he decided to produce monotypes. In a 1925 letter to Walker he wrote, "I am sending you a small Christmas card of my own. It is a monotype ... retouch[ed] with gouache. I paint a sketch in oils on a piece of linoleum, just as I would paint in oils on canvas or panel, then take a piece of Chinese paper (which is absorbent), put it down on the sketch ... and run it off the etching press. It gives the effect of a water-colour and the broadness of the brushwork of oils with great brilliancy and transparency of tones which cannot be had with water-colours or oils ... By studying very closely Degas' work, I found out that he first made a monotype then touched up all through with pastels to heighten and accentuate the colour."

In *Dog Team* (above), Gagnon used sweeping diagonal brushstrokes to suggest the force of the blowing snow that obliterates land and sky and leaves the man and dogs floating disconcertingly in a whirlwind of space. Gagnon redrew the figure of the man and added touches of red paint to highlight his clothing and the dogs' harnesses. The book's richly coloured illustrations were largely derived from his sketches of Charlevoix, although the novel's action took place in Alaska. Although the final product was deemed a great success, Gagnon's high expectations for the quality of the printed images were not met, and he grumbled to friends how he had been tricked by the printers who took short cuts. Rejecting any kind of mediocrity, Gagnon insisted that many images be redone, thus prolonging the process and creating publishing delays.

Maria Chapdelaine: 1929–1933

Even before he had completed the work for *Le grand silence blanc*, the publisher, Mornay, mentioned that he would be interested in having Gagnon illustrate Louis Hémon's 1913 novel, *Maria Chapdelaine*. But after Gagnon's experience with this first book, a second seemed unlikely. Writing to Brown in March 1928, he declared, "Thank God! My book is finished … It will be a jolly long time before I ever think of doing another." He also continued to insist that he wanted to devote himself to painting. In June 1929, however, Gagnon wrote again to Brown, spelling out his conditions for accepting the project: "I am to do the book as if it were for myself … also the right to keep the original drawings … I want a process no matter what it will cost that will give perfect reproduction of the originals."

Maria Chapdelaine is set near Péribonka in the Lac Saint-Jean region of northern Quebec, where Hémon, a native of France, had worked briefly as a handy man. The story is centred around the family of Maria Chapdelaine, the eldest of six children raised on the frontiers of the French-Canadian settlement of Quebec. The book is a chronicle of their relationship with nature, their social customs, and their hard life on the land over the cycle of the seasons. It also explores Maria's quest for love and her questioning of her isolated rural life.

Although Gagnon did not visit Péribonka until 1938, he readily saw in Hémon's story a reflection of the lives of people he observed working in the forests, farms and villages in the Charlevoix region in the early years of the twentieth century. He created intensely detailed, highly coloured illustrations for the book and drew on his excellent visual memory and copious collection of sketches and photographs taken

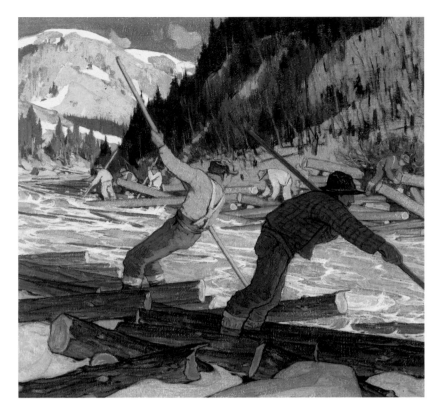

The Great Drive c.1928–33

Mixed media on paper; 24.2 x 25.0 cm. McMichael Canadian Art Collection, Kleinburg. 1969.4.20. Gift of Col. R.S. McLaughlin.

over the years. In compositions such as *The Great Drive* (above), men balance precariously on the logs, creating a diagonal thrust as they deftly push against their poles. They are generalized types, not individuals, and affirm the perennial struggle of humanity against the forces of nature. Choosing materials that would best convey the spirit of the subject, Gagnon used gouache for the water and sky, and pastel and pencil crayon for the figures with their checkered shirts and colourful socks. In *Burning Stumps* (page 52) the men toil to clear the land high above the river, the soaring hot flames juxtaposed against the cool flow of the river below.

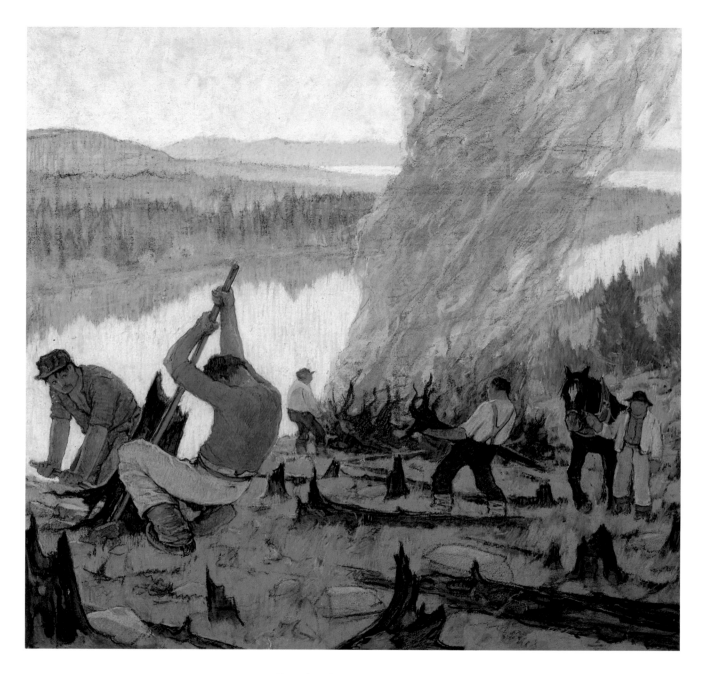

Burning Stumps c.1928–33

Mixed media on paper; 25.7 x 25.6 cm. McMichael Canadian Art Collection, Kleinburg. 1969.4.18.
Gift of Col. R.S. McLaughlin.

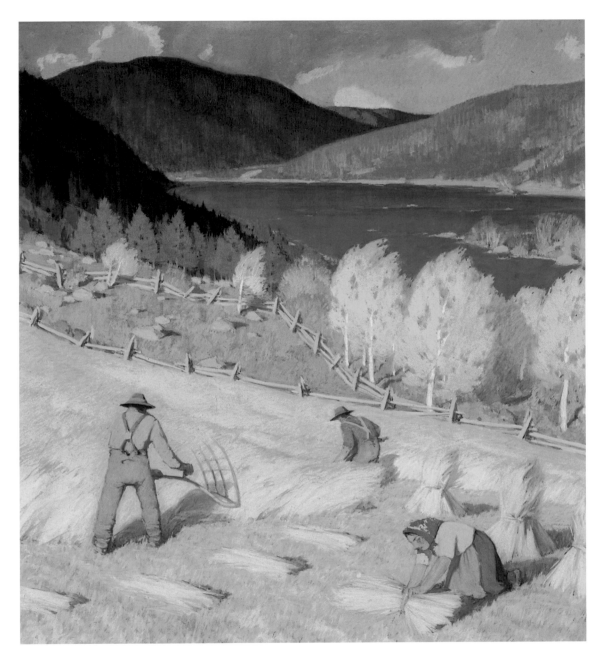

Harvesting c.1928–33

Mixed media on paper; 25.1 x 22.9 cm. McMichael Canadian Art Collection, Kleinburg. 1969.4.27.
Gift of Col. R.S. McLaughlin.

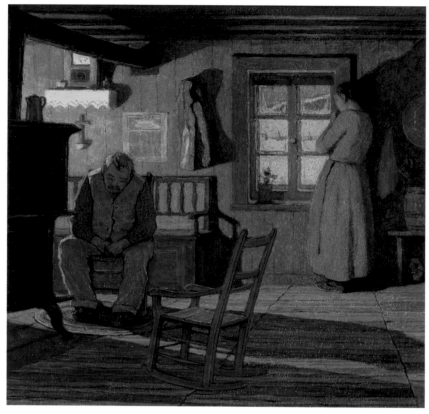

A Lonely House c.1928–33

Mixed media on paper; 23.1 x 23.3 cm. McMichael Canadian Art Collection, Kleinburg. 1969.4.53. Gift of Col. R.S. McLaughlin.

Methodical and absolute in their dedication to their task, they labour arduously with an almost pious submission to the laws of nature.

In *Harvesting* (page 53), men and women work together in the hot September sun, cutting and bundling the oats and wheat. With their stocky figures and enlarged proportions (compared with the scale of nature), they recall the depictions of industrious peasants seen in the art of the fifteenth century Flemish painter Pieter Breughel the Elder. Gagnon's refreshing use of warm yellows, greens, reds and clear blues

echoes the description in Hémon's text and captures the joys of an easier life during the short reprieve from the harshness of winter. As art historian Ian Thom has noted in his book on *Maria Chapdelaine,* Gagnon's "miniature paintings," with their jewel-like colour and meticulous description of the habitants' seasonal activities, could also be compared with "medieval illuminations such as *Les Très Riches Heures* of the Duc du Berry."

Although scenes of interiors are few (seven out of fifty-four), they are more closely linked to Hémon's narrative than are many of the exterior landscapes that echo Gagnon's earlier paintings. In *A Lonely House* (left), Gagnon made dramatic use of light from the oil lamp to cast the long shadows of the grieving husband across the picture plane. The mother is symbolized by her poignant absence, her empty chair engulfed by the shadow of the wood stove. Maria stands alone at the window gazing forlornly at a snow-covered landscape, contemplating her loss and uncertain future. Gagnon's dealer, William R. Watson, marvelled that the "knowledge shown in many of the illustrations is tremendous, and your memory for details of costumes, carpets, bedcovers and furniture shows that you have not forgotten Quebec through the years in Parisian exile."

The book was scheduled to be published in 1931, but by January of that year only fifteen of the fifty-four illustrations had been printed. As before, Gagnon was adamant that the quality of the individual illustrations be maintained in the printed books. In letters, he bitterly complained of ill health from working on the drawings at night, and of spending long hours supervising the printers during the day. "Lucile has warned me that if I start another book she will divorce me," he wrote to his dealer. "No need of such a warning, I am fed up with book illustration for the rest of my days.

The whole thing is a great disappointment to me as I wanted to do something really fine with 'Maria' at any cost." Finally, by the spring of 1933, Gagnon announced the completion of *Maria Chapdelaine*. "Mornay is very disappointed at not being able to keep the originals … I have had offers from American & French collectors but I am in no hurry to dispose of them. They are valuable documents to me in my work."

In the photograph of a smiling Gagnon at the 1938 opening of the exhibition of his illustrations for *Maria Chapdelaine* in Ottawa (page 47), the trials and years of toil were far behind him. Deluxe copies of the book sold quickly, and Gagnon's work was widely acclaimed. Writing in the introduction to the catalogue, Wilfrid Bovey stated that Gagnon's pictures "have told a story of its own had *Maria Chapdelaine* never been written. The spirit of the land guided the artist's brush."

Vagabonding through Europe: 1926–1936

Between 1926 and 1936, Clarence and Lucile travelled widely across the continent, and despite the artist's attraction to old world techniques and pre-industrial craftsmanship, Gagnon enthusiastically embraced "motoring." This ardent "vagabonding," as he called it, was linked as much to his desire to secure new subjects for his art, as it was to his natural curiosity about places that served his passions of fishing and hiking. Until his return to Canada in 1936, his letters home chronicle his views of the terrain and local people he encountered throughout his travels. He returned many times to Switzerland and to Scandinavia. In the fall of 1927 he wrote to Scott that his travels to rural Switzerland "somewhat reminded me of Baie-Saint-Paul. The peas-

ants are much like our 'habitants.' We find here blueberries, rag rugs, *catalognes,* maple trees (without the sugar) and lots of churches …"

In another letter to Scott, two years later, Gagnon recounted an itinerary that took them from Paris to Belgium, the Netherlands, northern Germany, Denmark, and Norway and Sweden: "I was particularly anxious to see the Skansen, the Folks Open Air Museum in Stockholm where old peasant houses were brought and set-up again with the worn fittings, used furniture, costumes, in a large park right in the centre of town … I wish we could get our people in Canada interested in a similar undertaking."

While many drawings from Gagnon's journeys capture picturesque villages, colourful oil sketches affirm his attraction to wilderness spots probably encountered on his fishing excursions. Writing to Watson in late 1934, Gagnon noted that the Scandinavian scenery "is of a serene grandeur, our Laurentians and Saguenay are a puny imitation of it." In *Mountain Stream, Dalen-Kelemark, Norway* (page 56), painted the following year, a tranquil mountain stream flows around a solitary island whose pine trees and surrounding forest recall Canadian terrain. In his lecture at Gagnon's memorial exhibition, Jean-Marie Gauvreau remarked, "In the sketches brought back from Norway, scarcely larger than a postcard, there is astounding energy and verve; a freshness of tone that is truly voluptuous, rapid and seductive."

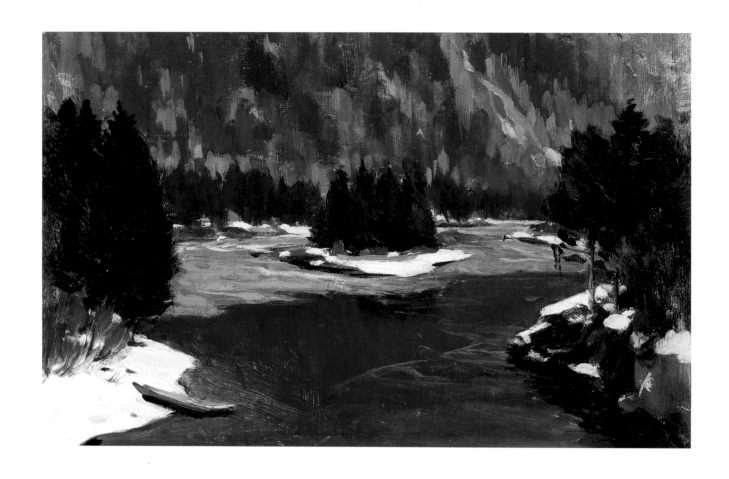

Mountain Stream, Dalen-Kelemark, Norway 1935

Oil on panel; 15.0 x 22.0 cm. Private Collection. Photo: Roch Nadeau.

Five: Return To Canada, 1936

Gagnon often wrote of missing Baie-Saint-Paul and the "whiff of the Jack Pine air," but exhibitions, book illustration and the enjoyment of exploring Europe continually prolonged his stay. Although most of his correspondence deals with the joys and headaches of travel, other letters refer to the economic depression, unemployment, strikes and constant "rumblings of war." Gagnon, however, remained undeterred in his Paris studio, escaping when he could to the peaceful wilds of Scandinavia. Only in late 1936 with the news of his father's death, did Gagnon return home in order to settle the estate. The only works he took with him were his illustrations for *Maria Chapdelaine*, which would garner rave reviews when exhibited in Quebec and Ottawa in 1938.

Gagnon's return to Montreal was feted in the daily papers. *La Presse* mentioned that he planned to stay only a few months and that in his travels to Switzerland and Scandinavia, he always found his "French Canada." *The Gazette* recognized him as "one of Canada's most distinguished painters" and noted that the Arts Club of Montreal held a reception in his honour. Clarence and Lucile settled in her parents' Montreal home in Westmount, a house coincidentally designed by Gagnon's architect brother, Wilford.

Gagnon visited Baie-Saint-Paul, but he no longer felt at home there. A few years before his return to Canada,

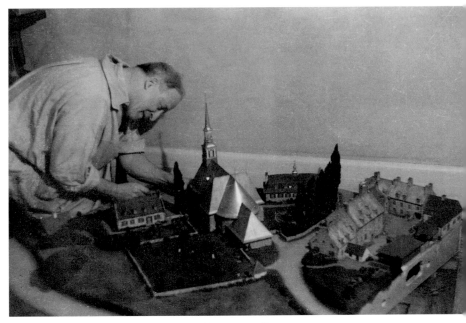

Gagnon working on his Tercentenary model 1939–40. *Collection Bibliothèque nationale du Québec. Fonds Jean-Marie Gauvreau.*

he had written to Brown: "I feel terribly sad when I hear my Baie-Saint-Paul is overrun with artists who imagine they can paint the French stuff. In order to do it well, you must have been born there and taken root in the soil." Even though Gagnon was an outsider to habitant life, he objected to the work of artists he didn't know, among them Jori Smith and Jean-Paul Lemieux, both excellent painters but not of his generation. More

Autumn, Baie-Saint-Paul (study) 1938

Oil on panel wood; 11.7 x 18.3 cm. Musée national des beaux-arts du Québec. 46.110. Photo: Patrick Altman.

important he was saddened by the modernization of the region and the disappearance of the old houses. The growth of the tourist trade contributed to the commercialization of the habitant arts, compromising originality. His relationship with the people of Baie-Saint-Paul had also changed. He was infuriated by their use of his paintings as compositions for their hooked rugs. In a 1938 letter to Martin Baldwin, curator at the Art Gallery of Toronto, he demanded "a stop to abuses of all kinds concerning the reproduction of artists' work with and without consent," and to the appropriation of artists' works "by hooked rug makers, jig-saw puzzles, candy box covers, cigar wrappers."

Rather than look for remnants of his old Baie-Saint-Paul, Gagnon quit the village and headed for the hills. In works such as *Autumn, Baie-Saint-Paul* (above) he found solace in the amber-hued grandeur of the Laurentians that shelter the scattered farms and lush green fields.

FROM THE BRUSH TO THE PEN

From the time of his return in 1936, Gagnon's pen, rather than his brush, became his primary tool of creative expression. City-bound with legal matters related to his father's estate, he wrote extensively on art and became an active champion of Quebec's "national" heritage. He was not alone. Since the late nineteenth century, scholars, enthusiasts and artists from across the country had expressed concern over the waning

of indigenous as well as various settler cultures. Emily Carr, for example, observed the threat to Northwest coast Aboriginal culture and made it the subject of her art about the time Gagnon became attracted to the habitant arts of Baie-Saint-Paul. The prominent ethnologist Marius Barbeau made his first trip to the Charlevoix region in 1916 and later made extensive recordings of old Quebec folksongs. In 1927 and 1928, Barbeau organized multidisciplinary folksong and handicraft festivals to which Gagnon lent his paintings. In 1936, Gagnon's own views on the importance of indigenous craft were further fuelled by his meeting with Jean-Marie Gauvreau, director of the École du Meuble, the Montreal school for art and design and principal champion of the arts and crafts revival in Quebec.

In a letter to Duncan Campbell Scott dated late in 1938, Gagnon enumerated the obstacles to painting: "I had four lectures to prepare and give: 1st one at the Arts and Letters Club on the 'Technique of Colour,' 2nd one at the Art Gallery on Morrice, 3rd one at the Handicraft Society on the Revival of Handicrafts in Quebec, 4th a radio talk on Suzor-Coté. I also drafted a plan to make the Île d'Orléans a national historical park."

Although the Île d'Orléans proposal did not materialize, it affirmed Gagnon's support of Quebec's "patriotic movement," and the need to sustain "the study of our ancestral customs and mode of living, our rural arts, and that of our historical and artistic treasures." The press enthusiastically received Gagnon's proposal as part of the growing nationalist movement in Quebec in the 1930s. Alfred Ayotte wrote in *Le Devoir:* "From the national and nationalist point of view, and from the perspective of 'Québécois pur,' this could be an important factor in maintaining our ancestral tra-

ditions." But Horatio Walker, the island's most prominent resident, told Gagnon "to cut it out … if anyone is going to save this island, we ourselves will see to it!"

Undaunted by the failure of the Île d'Orléans proposal, Gagnon continued to lobby for the endurance of rural artistic traditions, and in 1939 he produced another paper, "For the Revival of Canadian Folk Art." Gagnon praised the beauty of objects created by women over the winter months and recognized the pride displayed in "the brilliantly coloured and finely ornamented gear." Commenting on the value of poor roads and a slower way of life, Gagnon seemed to be describing the world of his paintings – an idealized and nostalgic view of traditional rural life. He acknowledged the important work of organizations such as the Canadian Handicraft Guild to promote Aboriginal and rural arts and crafts, but warned of "government support" that could foster over-commercialization and corruption of the arts of the habitants. He saw salvation in the establishment of open-air museums, modelled on the Scandinavian examples, where traditional architecture and people in habitant dress could provide a context for the appreciation of the roots of French-Canadian culture.

Gagnon's preservationist tendencies and advocacy for tradition were linked to his contempt of the more radical tendencies of modern and early twentieth century European art. Attitudes voiced in his 1939 speech, "The Bluff of Modernist Art," can be traced to letters from Paris many years before. Writing to Walker in 1925, he had exclaimed, "Holy Moses! A worse show could not be better arranged, cubists, super-realists, dadaists … and all the 'isms' of the world were there except a decent canvas … What an appalling decadence!" In the 1939 speech delivered to the Pen and Pencil Club, Gagnon denounced Cézanne, Vincent van

Gogh and Gauguin, referring to them as "mental cripples" made grand by their dishonest eulogists. Matisse is a "torturer of the human form," he said, and Pablo Picasso, "a devil … colossal in his audacity." At the heart of Gagnon's objections were the artists' distortion of nature and his belief in notions of "honesty" in art.

Although the popular press supported Gagnon's interest in the revival of folk art, the avant-garde had no patience for his intolerance of modern movements. Many Montreal artists, such as Alfred Pellan and John Lyman, promoted art that celebrated the "sensibility and imagination of the individual" and the primacy of the formal elements of art over illustrational content. On April 30, 1939 – coincidentally, the day after Gagnon's antimodernist talk – Lyman opened the first exhibition of the Contemporary Arts Society, bringing together artists committed to international modernism. In his letter to *The Standard*, Lyman dismissed Gagnon's views and provided a long list of eminent curators and writers, from Sir Kenneth Clark to Virginia Woolf, as examples of the widespread enthusiasm for modern art. Years later, when Gagnon's widow investigated the possibility of compiling Gagnon's polemics in a single publication, Duncan Campbell Scott wisely advised against it. "To my mind," Scott wrote, "Clarence's reply to all that is false and unworthy in modern art is his own work; the diversity and beauty of that will stand when all the petty controversy over the aims and ideals of other artists will have been forgotten."

In the year Gagnon delivered his speech against modern art, he was already hard at work on a proposal to the Montreal Tercentenary Commission to build a scale model of a historic Quebec village. It would be constructed on Mount Royal, in the centre of the city.

Inspired by Skansen, the historic Swedish village he had so admired, Gagnon's outdoor museum would consist of thirty-seven buildings from different locations and eras of Quebec architecture.

In the photograph on page 57, Gagnon lovingly tends to the details of the model – nicknamed by his friends, "St. Clarence de Gagnon" – in preparation for its display at an exhibition of Quebec handicrafts in the summer of 1941. Unfortunately, Gagnon could not attend the unveiling on account of exhaustion and pain that doctors could not identify. From that time on, his decline was swift. By the fall he was bedridden, and by December he was hospitalized with cancer of the pancreas, from which he died on January 5, 1942.

Gagnon's death was greatly mourned. The *Montreal Star,* along with scores of other newspapers across the country, lamented the demise of "one of the most distinguished artists of the Dominion … and a serious loss to Canadian art." By April 1942, plans were under way at the Musée de la Province du Québec for a large memorial exhibition that would travel to the nation's major art galleries. Newspapers reported astounding attendance, with long lines of people waiting to see the *Maria Chapdelaine* illustrations for which Gagnon was so famous. Quebec's *Chronicle Telegraph* stated that more than seven thousand people had visited the exhibition – "a great tribute to the memory of one of our greatest artists." For the people of Canada now into their third year of world war, Gagnon's idyllic visions of a simple rural past were a solace to those experiencing fear, sadness and loss. The colourful representations of the cultivated soil, home and hearth embodied the quiet beauty of the Canadian landscape, a "peaceable kingdom" to quote Gagnon's great mentor, Horatio Walker, where all could take refuge.

Gagnon's Legacy

Although Gagnon was by no means the first artist to visit the Charlevoix region, he must be credited with creating the first significant following of artists there. In the early 1920s, Gagnon's residency in Baie-Saint-Paul prompted visits by A.Y. Jackson, who later returned with other well-known artists. American artists were also attracted to the splendid landscape of the region and, like their Canadian predecessors, were fascinated by the picturesque customs of this largely isolated population. While most artists came to further their art, the painter Jean Palardy turned to research, opening doors to new scholarship with his 1963 publication about the early furniture of French Canada. Palardy was also the conduit for Alfred Pellan, who created a series of paintings depicting the region's children at the same time that his modernist work was being acclaimed in Montreal.

Gagnon's attraction to the handicrafts of Charlevoix spawned a revival that not only promoted a widespread appreciation of women's domestic arts, but also encouraged local artists, such as the Bouchard sisters and Yvonne Bolduc, to take up the brush and the chisel, perpetuating their own views of the people and daily rituals in the community. For all these individuals, Gagnon's work and fame conveyed to them that their lives and environment were worthy subjects for works of art. After Gagnon's departure, artists such as Jori Smith and Jean Palardy continued in his path, nurturing the creative spirit of the region.

Through his painting and illustrations for *Maria Chapdelaine*, Gagnon succeeded in immortalizing a pre-industrial view of Charlevoix that celebrated both the rural architecture and the ancient traditions. And as Albert Robson reminded us, this was not "mere rural topography; there is insight, sympathy and understanding in every stroke of the brush." In his art, Gagnon preserved images of a way of life that, by the time he died, was gradually disappearing. If, as Marius Barbeau stated in 1916, the Charlevoix region was slowly waking from a long sleep, then in Gagnon's art we can slip back into a dream, delighting in the colours and tranquillity of times past – just as Gagnon did in the early decades of the twentieth century.

Selected Sources and Further Reading

Baker, Victoria. *Scenes of Charlevoix 1784–1950*. Montreal: Montreal Museum of Fine Arts, 1981.

Boissay, René. *Clarence Gagnon*. La Prairie: Éditions Marcel Broquet, 1988.

Bovey, Wilfrid. Foreword to the *Catalogue of the Exhibition of fifty-four original paintings by Clarence Gagnon Illustrating the Book "Maria Chapdelaine."* The Art Association of Montreal, 1938.

Braide, Janet. *William Brymner 1855–1925: A Retrospective.* Kingston, Ont.: Agnes Etherington Art Centre, Queen's University, 1979.

Brown, Eric. "Studio Talk: Toronto," in *The Studio* (London), Vol. 49, 1919.

Des Gagniers, Jean. *Charlevoix – pays enchanté*. Sainte-Foy: Les Presses de l'Université Laval, 1994.

Gagnon, François-Marc. *Charlevoix – Histoire d'Art 1900–1940*. Baie-Saint-Paul: Le Centre d'exposition de Baie-Saint-Paul, 1995.

——. *Clarence Gagnon 1881–1942*. Baie-Saint-Paul: Le Centre d'exposition de Baie-Saint-Paul, 1992.

Gauvreau, Jean-Marie. "Clarence Gagnon à la Baie-Saint-Paul." Mémoires de la Société Royale du Canada, Vol. 38, Section 1, Série III (May 1944).

——. Lecture at the National Gallery. Ottawa, December 1942. Typescript, National Gallery of Canada Library.

Gustavison, Susan. "The Picture Frames of Clarence Gagnon." *The Journal of Canadian Art History*, Vol. 12(1), 1989.

Hémon, Louis. *Maria Chapdelaine,* translated by Alan Brown. Montreal: Tundra Books, 1989.

Hill, Charles C. *The Group of Seven: Art for a Nation.* Ottawa: National Gallery of Canada, 1995.

Jackson, Alexander Young. *A Painter's Country: The Autobiography of A.Y. Jackson*. Toronto: Clarke, Irwin: 1958.

Karel, David. *Horatio Walker*. Quebec: Musée du Québec, 1987.

Musée McCord Museum Archives: Clarence Gagnon fonds (P116). Typescripts of speeches by Gagnon: "Theory and Chemistry of Colour in Art" (1937); "On Morrice" (1938); "The Île d'Orléans as an Historical National Park" (1938); "The Grand Bluff of Modernist Art" (1939); "For a Revival of Canadian Folk Art" (1939).

National Gallery of Canada Archives: NGC fonds, Correspondence with Clarence Gagnon.

Reid, Dennis. *A Concise History of Canadian Painting*. Toronto: Oxford University Press, 1973.

Robson, Albert H. *Clarence Gagnon*. Toronto: Ryerson Press, 1945.

Scott, Duncan Campbell. "Clarence Gagnon, Recollection and Record." *Maritime Art*, Vol. 3(1), October–November 1942.

Thom, Ian. *Maria Chapdelaine Illustrations: Gagnon, Suzor-Coté*. Kleinburg, Ont.: McMichael Canadian Art Collection, 1987.

Tovell, Rosemarie. *A New Class of Art: The Artist's Print in Canada, 1877–1920*. Ottawa: National Gallery of Canada, 1996.

Trépanier, Esther. "The Expression of Difference: The Milieu of Quebec Art and the Group of Seven." In Michael Tooby, ed. The True North – Canadian Landscape Painting 1896–1939. London: Lund Humphries Publishers, in association with Barbican Art Gallery, 1991.

Index